AIRBRUSHING

AIRBRUSHING

BY CARL CAIATI

TAB BOOKS Inc.

BLUE RIDGE SUMMIT, PA. 17214

Also by Carl Caiati from TAB BOOKS Inc.

No. 1915 *Video Production—The Professional Way*
No. 1955 *Advanced Airbrushing Techniques Made Simple*
No. 2142 *Customizing Your Van—3rd Edition* (with Allan Girdler)
No. 2122 *Basic Body Repair & Refinishing for the Weekend Mechanic*
No. 2132 *Installing Sunroofs and T-Tops*

FIRST EDITION

THIRD PRINTING

Printed in the United States of America

Copyright © 1983 by TAB BOOKS Inc.

Library of Congress Cataloging in Publication Data

Caiati, Carl.
Airbrushing.

Includes index.
1. Airbrush art. I. Title.
NC915.A35C34 1983 751.4′94 83-4882
ISBN 0-8306-0155-4 (pbk.)

Contents

Acknowledgments

Working along with me on this project were many people throughout the airbrush field who contributed their time, unstinting assistance, and illustrations.

My personal thanks go especially to John Fennell of Badger Airbrush who provided a wealth of material and assistance.

A special note of thanks also goes to Deirdre Carolan, Advertising and Public Relations Manager of Paasche. Deirdre proved beyond any doubt the efficiency of a thoroughly cooperative, knowledgeable, and astute P.R. manager.

I am particularly grateful to the artists and airbrushers represented within these pages. Without them and their representative work, this book would have been bland indeed.

I am greatly indebted to Jacqueline Metz for her excellent art, which she made available to me for reproduction. Jackie is one of the foremost retouchers in the country as well as an accomplished and successful artist.

The Iwata Airbrush Company also lent assistance by providing necessary material and photographs.

Last but not least, special thanks go to my typist, Fredna, who took time between teaching school and being a mother to type all the material that went into this extensive book.

This book is dedicated to my kid sister Nora
who through the years has proved to be "the Best."

Introduction

The airbrush—once the magical, mystical tool of the realist artist and the classic photographic retoucher—has evolved into one of the standby implements of portrait artists, landscape renderers, op-art aficionados, automotive and motorcycle customizers, and many hobby and craft buffs.

With over a hundred years of representation on the American scene, the airbrush as we know it today has undergone very minor structural changes since its introduction into the art field circa 1883. Its design and working concepts remain the same save for minor variations, usually instituted by various competing manufacturers.

An airbrush is basically a miniaturized spray gun, and its charisma is attributed primarily to the fact that anyone can achieve artistic, or at least adequate, design effects (be they complex or elementary) by familiarization with the airbrush's capabilities and operation. Ease of operation may be acquired in a short time simply by exercising preliminary drills and rendering processes.

This book is both a basic and a technical manual. It presents basic standard drills and exercises, and then carries you through the more sophisticated and exacting stages of airbrush art in order to broaden your scope of expertise.

The more critical and exacting rendering approaches are delineated and simplified with explicit step-by-step illustrations, which break the processes down to the most simplified forms.

A fair amount of space is devoted to the disassembly and maintenance of the airbrush and some attention is given to basic troubleshooting. A great many airbrush books skirt these areas, classifying them as trivia. Many beginners are hampered by the often inadequate instructions provided by some airbrush manufacturers. I have, therefore, incorporated what I feel is the most expansive and definitive piece devoted to major as well as minor maintenance.

This book does not delve into areas covered in many standard art and media books. It does not stress the basics of composition, perspective, color, design, or other related aesthetic subjects.

Enough specialty books have been written on these subjects to fill an armory, and they are readily available at well-stocked art stores.

I deal mainly with techniques and practices relative to the air tool itself. Some specific design motifs and effects are touched upon, however, since they are atypical to airbrush rendering.

Air supply, another critical factor, is discussed, with greater attention given to the sounder and more efficient forms. A comprehensive section also lists some of the more formidable accessories desired and available for use in conjunction with the airbrush.

A few manufacturers produce distinctly unique specialized airbrushes, and these out-of-the-ordinary airbrush utensils are featured and explored.

In short, this informative manual provides you with an in-depth study of the elements and techniques of airbrushing and should assist both amateur and professional airbrush enthusiasts alike.

History of the Airbrush

According to historical data, the origin of airpainting goes back to the Stone Age, when prehistoric man allegedly blew pigments through hollow tubes (probably bones or reeds) to create their cave artwork. Unfortunately, prehistoric man was not well versed on the Bernoulli principle of spraying, on which the majority of airbrushes are based, so his results must have been primitive indeed.

More recent findings attribute the original basic airbrush concept (now vastly improved upon) to Abner Peeler, who designed the airbrush in 1878. He later sold the world rights and patent to Liberty Walkup, who in turn founded the Rockford Airbrush Company in 1883 to provide airbrushes for the general public.

In 1893, Charles Burdick, an American, patented a similar device in England. Burdick was a proficient if not reknowned watercolor artist as well as an innovative inventor. His interest in the development of the airbrush was initiated by his desire to successfully apply one color or wash over another without intermingling the two colors or discoloring one, the other, or both coatings. This can be a problem in watercolor rendering, but Burdick circumvented this by using spray applications of colors by airbrush after making minor improvements to the tool itself. Burdick's particular contributions to airbrush design and structure (still used today) were the centralized paint tip, the needle for paint metering, and the air cap.

An air supply for early airbrushes was provided by press-on hoses consecutively connected to air pumps and other pressurized sources. Paint or pigment thinned to watery consistency was retained and gravity-fed by color cups that became a permanent, integrated part of the airbrush today. So sound and sure was this basic paint-feed principle that to this day gravity-feed top cup airbrushes are successfully marketed and highly favored by some contemporary airbrushers.

At the turn of the century, while still in its infancy, airbrushing became an acknowledged facet of photo retouching and art rendering. One of the earliest and foremost airbrush manufacturers of that period was Thayer and Chandler, a company that has successfully survived to this day.

In August, 1905, the U.S. Patent Office granted Jens Passche his first airbrush patent. Well versed in all phases of airbrush refinement, Paasche designed a revolutionary new airbrush (known today as the AB Turbo, Paasche's airbrush design is still widely recognized and used with almost no modifications on the original design concept). Standard airbrushes at that time based their operation on the Bernoulli principle. Paasche's AB model was based on his own applied innovation: an air-driven miniature turbine that is able to deliver liquid color slowly and in minute amounts for extremely fine line rendering. Never content to stand about idly, Paasche worked constantly and efficiently in his workshop, always experimenting and creating (Fig. 1-2). His labors again bore fruit when in 1920 he introduced and started marketing the air eraser, the only sound tool for toning down or removing airbrushed washes. The air eraser is a miniaturized

Fig. 1-1. Jens Paasche at age 45 (courtesy Paasche).

Employed by Thayer and Chandler at the turn of the century was a gunsmith of Norwegian origin who had just migrated to the United States. His name, which came to be recognized throughout the airbrush industry, was Jens Paasche (Fig. 1-1). Paasche, an innovative inventor and craftsman in his own right, soon tired of his restrictive position at Thayer and Chandler. He left the company to become the cofounder of the Wold Airbrush Company. After a year, the Wold-Paasche association deteriorated and Paasche sold his interest in the company in order to form his own. It was Paasche's wish and intention to create superior, highly refined airbrushes and many ideas were fermenting in his mind along these lines.

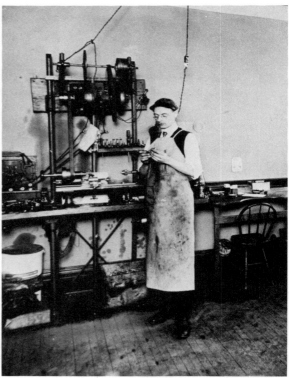

Fig. 1-2. Paasche at work in his laboratory and machine shop (courtesy Paasche).

sandblaster that works just like an airbrush, but it blows dried powder instead of liquid. The Paasche AB Turbo and Air Eraser are covered in depth in Chapter 2 in the section on specialty airbrushes.

Suction-feed was the next feature to be introduced in airbrushing, a method perfected by Alan DeVilbiss and consequently adopted by some prominent manufacturers who could now offer a variety of airbrush models for more varied and widespread applications.

From the 1930s to the 1940s, the airbrush mantained a status quo, undergoing almost no changes and modifications except in styling.

The late 1950s found interest in airbrushing growing, spurred on by phenomenal growth in the hobby and craft fields. The airbrush soon took a prominent place on the workbench of the average hobbyist and craftsman as painting with "hair" brushes became passé. Superior results were achieved with the airbrush; it eliminated the telltale brush marks that were undesirable to discerning craftsmen. The airbrush soon became solidly entrenched in the model airplane, boat, railroad, diorama fields as well as in decoupage, fabric, and ceramic fields.

Realizing the potential of the airbrush as a creative tool for the masses, Walter A. Schlotfeldt, a machinist and tooling engineer of note, formed the Badger AirBrush Company in the early 1960s, and it soon became a large-scale supplier of quality airbrushes. Schlotfeldt, also an innovative "dabbler," added some refinements of his own to the Badger airbrushes. In 1964 Badger was on a heavy production schedule with the 100XF, 100IL, and 150 models enjoying great popularity in the hobby, craft, and commercial fields. Featured on these units were Teflon needle bearings (for better seating and slide action), Teflon head seals (eliminating the need for beeswax to ensure air sealing), and a one-piece trigger.

The next big airbrush boom came in the late 1960s, hot on the heels of the customizing craze. Custom painting vans, cars, and motorcycles became the rage, with graphics and murals the cosmetic effect choices. Since finely rendered murals were desired (particularly on vans), the most viable means for executing the fine detailed work in automotive lacquer was the airbrush.

Today, there is still a steady interest in airbrushing in general. Many schools offer both beginning and advanced art courses in airbrush technique. Many of the popular and acknowledged methods are presented in this book, which should serve to interest and enlighten the airbrush enthusiast.

Chapter 2

Anatomy of the Airbrush

Broken down into their common denominators, airbrushes are miniature versions of the spray gun, a tool more familiar to the average layman.

Like its larger counterpart the spray gun, the airbrush is a siphon-action tool based on the Bernoulli principle of forced spray technology. One corollary of the Bernoulli principle (which also applies to the lift of an airplane wing or the curve of a traveling baseball) states that the greater the speed of liquid flow, the lower the pressure realized. As speed is curtailed, pressure increases. A more simplified, understandable explanation of this theory is as follows: water (or any liquid) moves more rapidly through a narrower portion of a pipe or tube than it does through a wider segment, provided the liquid is confined to an equal level.

This is best illustrated by the fixative blower, a tool more familiar to artists. Artists, particularly those who render in charcoal and pastels, use the fixative blower to spray a fixative solution over drawings. The fixative seals the powdery medium to circumvent smudging or damage to the artwork. The fixative blower is placed in a nonhermetically sealed receptacle containing liquid (Fig. 2-1). As you blow into the horizontal section of the blower Fig. 2-1, *A*, a low-pressure area forms at the right angle junction of the two tubes (Fig. 2-1, *B*), drawing liquid up the vertical tube (Fig. 2-1, *C*). The liquid is forced up by atmospheric pressure acting on the surface of the liquid held in the receptacle. At point *B* in Fig. 2-1, the liquid and air atomizes, creating a working spray. This is the Bernoulli principle in its simplest form. The more sophisticated and structurally refined airbrush contains built-in controls that serve to vary the density and intensity of the atomized solution emanating from the tip of airbrush.

Airbrushes are primarily classified as single- or double-action with variations on each type.

THE SINGLE-ACTION AIRBRUSH

In the *single-action, external-mix nonadjustable-siphon* type, (Fig. 2-2) the valve or button only feeds air; paint and air are mixed or atomized externally (as with the fixative blower). Occasionally models of this basic type contain an adjustable

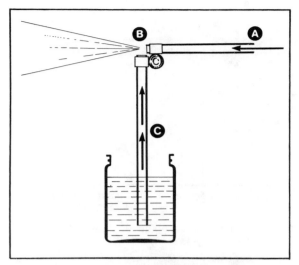

Fig. 2-1. The Bernoulli principle: air is forced into horizontal pipe at *A*, creating a low-pressure area at *B*, which in turn draws up liquid through vertical tube *C*.

paint feed cone, but at best, flow adjustment is limited. This primitive airbrush type is the least expensive and offers limited versatility. It is adequate for large-area, overall rendering and toning but severely limited for detailed or finer rendering.

The *single-action, external-mix, adjustable siphon* version (Fig. 2-3) is an improvement on the nonadjustable-siphon airbrush. It has a greater mixing range, provided by variable fluid-air adjusting components. Allowing greater flexibility in paint concentration and flow, this airbrush is ideal for general work, yet operationally superior to the basic single-action non-adjustable type.

The Badger 350, Binks 59, and Paasche Model H are examples of single-action, external-mix airbrushes.

Another airbrush that can be categorized with the standard single-action units, though more superior in concept and operation, is actually a good compromise between single- and double-action configurations. It is the *single-action, internal-mix* airbrush. One example is the Badger 200 (Fig. 2-4), which features *internal mixing* of air and paint plus a *needle* for paint-flow metering. A unit similar to the Badger 200 is the Thayer and Chandler Model E.

With both units, paint flow and spray width are regulated by rotating needle adjustment knobs located in the rearmost portion of the airbrush handle. Single-action airbrushes of this type come closest in versatility to the more defined double-action airbrushes.

Figure 2-5 provides a cutaway view of the Badger 200 single-action, internal-mix needle airbrush. Air is introduced into the airbrush by the depression of the trigger. This action enables air to flow, drawing up fluid and uniting it with the fluid in the head section where air and fluid atomize and are emitted in spray from through the tip. At the rear of the handle is the adjustment knob that controls paint flow and consequently spray dispersion. Though not as versatile or exacting as double-action, internal-mix models, this airbrush is capable of doing work as refined as that attributed to the more sophisticated types.

THE DOUBLE-ACTION AIRBRUSH

The epitome of airbrush excellence is the highly efficient *double-action, internal-mix, needle* type. Two distinct versions are available; the basic difference between them is the mode of paint containment, which influences the structural design to some degree.

The fine, detailing artist's mainstay and

Fig. 2-2. The Badger 250, a basic, simple airbrush.

Fig. 2-3. Single-action, external-mix airbrush.

Fig. 2-4. Single-action, internal-mix airbrush (Badger 200).

preference is the *gravity-feed cup* type containing a removable cup. The cup supplies paint (drawn in and assisted by the force of gravity) to the airbrush. Another preferred gravity-feed model features top-feed by means of a fixed cup that is an integral part of the airbrush body or shell (Figs. 2-6 and 2-7). Also very popular is the *bottom siphon-feed* version, which uses a large bottle or cup for paint supply, thereby allowing for greater amounts of paint to be stored efficiently (Figs. 2-8 and 2-9).

In the double-action airbrush, air flow and paint metering are controlled by a common valve or lever. Pushing down on the activating button starts the air flow. The further the button is depressed, the more air is emitted into the airbrush.

The coordinating air-paint trigger provides horizontal sliding action in addition to its up-and-down action. This integrated horizontal sliding action controls the amount of fluid dispersed into the airstream. When the lever is pulled all the way back, the maximum amount of fluid is allowed to flow.

The internal needle linked to the lever, in turn, assists in formulating spray width and fluid dispersion. The needle has a sharp point that tapers back about ½ inch to the width of the needle shank. As the needle is pulled back, the opening at the spray tip is enlarged, allowing a greater volume of paint to pass through the tip.

The combined up-and-down lateral action of the double-action airbrush has an instantaneous effect on width, density, and atomization of the air-fluid mixture and is controlled by simple forefinger manipulation of the control button. The internal intermixing of air and paint provides maximum uniformity of spray pattern and density. The experienced airbrush manipulator can quickly run the gamut from fine line to wide area rendering and realize excellent results.

Double-action airbrushes require more exper-

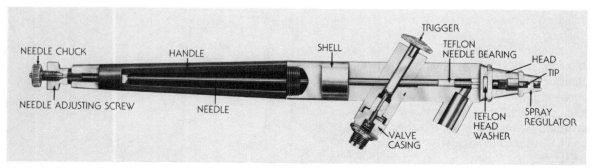

Fig. 2-5. Cutaway view of a single-action, internal-mix airbrush (Badger 200) (courtesy Badger Air-Brush Co.).

Fig. 2-6. Badger 100GXF.

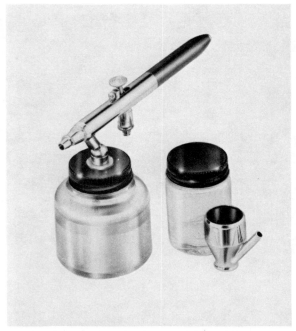

Fig. 2-8. Badger 150 with color cup options.

tise and care than their less sophisticated (but sometimes hardier) counterparts do. Inept fingertip control will adversely affect spraying precision. Fluid density and paint viscosity are also more critical with the double-action types. Proper and exact thinning (paint-to-solvent) ratios must be adhered to; some paints and pigments may require filtering or straining in order to pass through the

Fig. 2-7. Iwata HP-C (courtesy Iwata).

Fig. 2-9. Bottom-mounted jars offer more paint storage and are spill-proof.

7

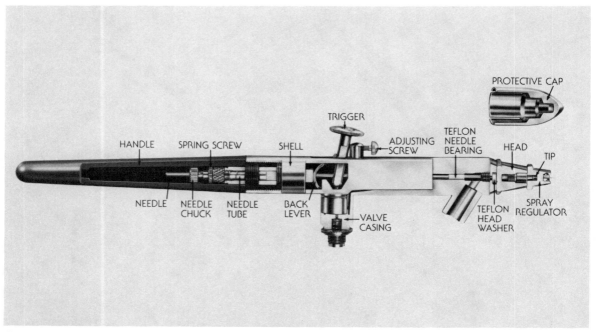

Fig. 2-10. Cutaway view of a double-action airbrush (Badger 150) (courtesy Badger Air-Brush Co.).

more confined passages without causing blockage that consequently causes aberrations in spray consistency and pattern. Double-action airbrushes must be scrupulously maintained, thoroughly cleaned, and regularly serviced.

All factors considered, the refined double-action units are most favored by both the professional and moderately talented enthusiast alike. They offer optimum versatility and are capable of yielding results superior to those of the single-action types. Figure 2-10 shows the anatomical structure of the typical double-action, internal-mix siphon airbrush. Other examples of current models are shown in Figs. 2-11, 2-12, and 2-13.

Fig. 2-11. The Paasche V airbrush (courtesy Paasche).

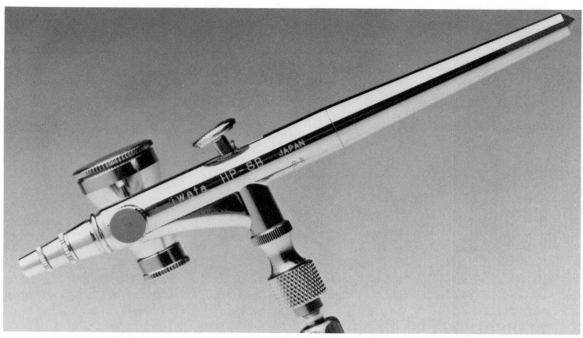

Fig. 2-12. Iwata HPS-B (courtesy Iwata).

SPECIALTY AIRBRUSHES

A few airbrushes are unique in operation. They are specifically designed for purposes not within the scope of standard airbrushes. The following are some of the more distinctive models applicable in specific situations.

The Paasche AB Turbo

The Paasche AB Turbo (Fig. 2-14) is the most distinctive, most unusual of the double-action airbrushes on the market. It is one of the finest as well as one of the costliest available.

Unlike standard double-action airbrushes, the

Fig. 2-13. Paasche VL (courtesy Paasche).

Fig. 2-14. The Paasche AB Turbo (courtesy Paasche).

AB Turbo does not operate on the Bernoulli principle. The oscillating needle action of the airbrush is instituted and governed by an integrated turbine that can attain up to 20,000 rpm. The turbine segment connects to a specially designed arm that pushes and pulls the fluid needle back and forth at the high speed. The air nozzle is located at an angle of approximately 90° to the needle tip.

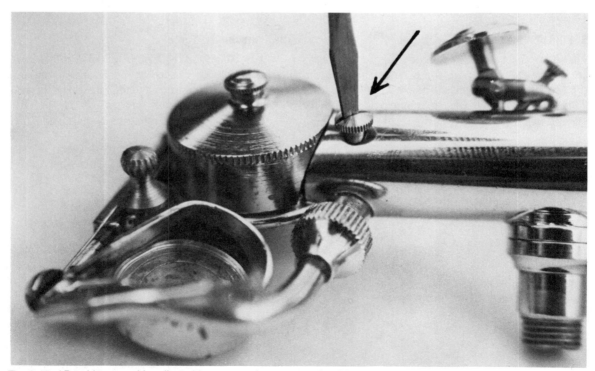

Fig. 2-15. AB turbine speed is adjusted by means of a screw setting (arrow).

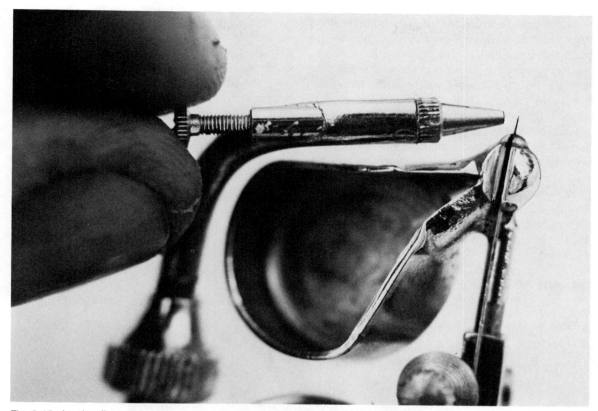

Fig. 2-16. An air adjustment screw at the rear of the air nozzle regulates stipple action.

While oscillating, the extremely fine needle picks up paint or dye that is gravity-fed from the cup into the needle channel. As the needle moves into the airstream, the paint is introduced into the air flow and transferred in an atomized state onto the surface or item to be painted. The air forces the liquid off the needle. As the needle retracts, it picks up more paint. Throughout operation this action is repeated at a high, steady rate.

The AB is an independent double-action airbrush, lever activated like the more conventional airbrushes. Downward pressure operates the air valve; pulling back on the lever allows the needle to advance further into the airstream. The further the needle is advanced, the greater the paint flow.

There are other external controls that must be adjusted separately. The turbine's speed is controlled by an adjustment screw directly behind the turbine housing (Fig. 2-15). An air adjustment screw to regulate stipple or the degree of spatter intensity is located at the rear of the air nozzle (Fig. 2-16).

For proper operation, the air compressor regulator should be set at 25 pounds for general work. To increase stipple effects, the air pressure should be lowered; higher pressures will provide finer atomization.

Before airbrushing, you may have to prime the AB in order to start the paint flow; you can use a brush to push paint into the needle slot or place your thumb over the paint cup opening in a pumping action, thus forcing the paint into the needle slot. To adjust the position of the color cup, loosen the cup retaining screw (Fig. 2-17) and adjust the cup angle.

The AB is an extremely delicate instrument and should be treated as such to ensure its longev-

ity. Care must be exercised when cleaning the unit, especially the needle. A bent or damaged needle point will cause frayed line patterns. Remove the needle by grasping it one-quarter of the distance from the tip with tweezer. Lift it gently out of the needle slot, and then pull it to the side a fraction of an inch, lifting it out of the walking arm slot (Fig. 2-18). To operate properly, the AB must be kept scrupulously clean and should be tuned regularly according to the instructions provided.

The AB is a truly refined tool strictly for the professional. It must be tuned occasionally and well maintained. It is designed for ultrafine work, needs skill to manipulate, and can handle only the finest dyes and paint media. It is unequalled for hairline rendering.

The Iwata HP-E2

The HP-E2 (Fig. 2-19) by Iwata is a heavy-duty, general-purpose airbrush and is basically designed for painting with lacquer, which can be detrimental to finer, more delicate standard airbrushes.

The HP-E2 has a wide nozzle orifice (0.8 mm) not prone to clogging and a large, removable fluid cup, two features desirable for lacquer painting. The HP-E2 is quick and easy to disassemble and equally easy to clean.

The Badger 400 Detail Gun

The Badger 400 (Fig. 2-20) is more closely related to the spray gun but is welcome in situations where the airbrush alone will not suffice. Airbrushers who specialize in large-area mural airpainting rely on the 400 for quick coverage or for airbrush procedures that must be carried out on a larger scale.

The 400, although larger than any airbrush, is

Fig. 2-17. Loosening screw to adjust cup angle.

Fig. 2-18. Removing the needle (see text).

capable of fine rendering that belies its cumbersome appearance. Two interchangeable needles and tips are available; using the finer of the two, the 400 is capable of fine detail work that previously was limited to the airbrush. A compressor more efficient than the standard airbrush compressor is necessary as an air source since the 400 requires about 40 pounds of air pressure in order to function properly.

The 400 is extremely popular with automotive paint customizers. It is trouble-free, durable, and virtually unsusceptible to clogging when used with automotive lacquers. Flexible enough to fill in and shade large areas, and equally adept for muralization and fine detailing, the Badger 400 is almost as versatile as the airbrush.

The Paasche AEC-K Air Eraser

The Paasche AEC-K Air Eraser is not an airbrush at all—it is almost a miniature sandblaster (Fig. 2-21). It is the only sound means of erasing

airbrushed tones and does so by removing or lightening them with a forced sand spray. The air eraser will eradicate fine lines or overall tone masses (Fig. 2-22). It can prepare surfaces so that paint will adhere better and can etch glass and Lucite plastic.

The air eraser is a single-action, suction-feed tool with a top-mounted, sand-retaining cup (Fig. 2-23). The sand is sucked by an internal tube into the body: compressed air draws the sand into and through the nozzle, using the Bernoulli principle. A set screw on top of the sand canister increases or decreases the amount of powder metered through the nozzle. The powder mediums usually used in the air eraser are fine pumice or aluminum oxide. For safety, goggles as well as a filter respirator mask should be worn when using an air eraser.

CHOOSING AN AIRBRUSH

The nucleus of the entire airbrushing system is the airbrush itself. Hence, careful consideration should be given to its selection. You must decide

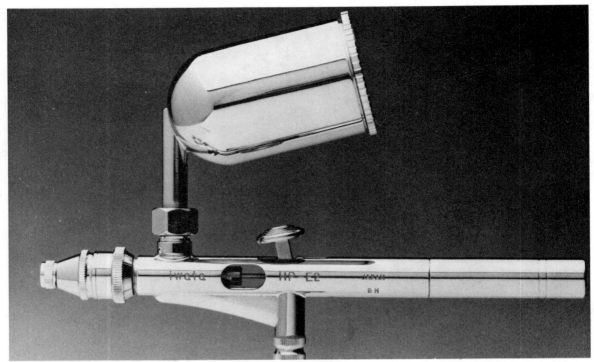

Fig. 2-19. Iwata HP-E2 (courtesy Iwata).

what function(s) it is to perform and what media (paint, for example) you plan to use with it. You must also determine if you will be using it for fine, detailed rendering or for general, overall work. An artist (or enthusiast) involved in portraiture or illustration, for example will most likely require an ultrafine airbrush able to execute discerning and intricate linework, whereas the more casual hobbyist or craftsman can get by with a simpler, less expensive unit not as adept at performing the intricate work the more sophisticated ultrafine airbrushes are capable of.

Keep in mind that all models and types have inherent advantages and disadvantages. It is difficult for me to recommend one particular airbrush as needs and prerequisites differ among individual airbrushers. It is also hard to give an unbiased opinion: I, like all my contemporaries, tend to favor some airbrush types over others.

You may begin the selection process by carefully researching and studying airbrush offerings;

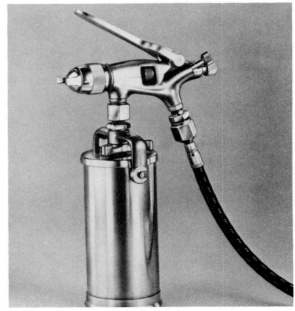

Fig. 2-20. The Badger 400 detail gun.

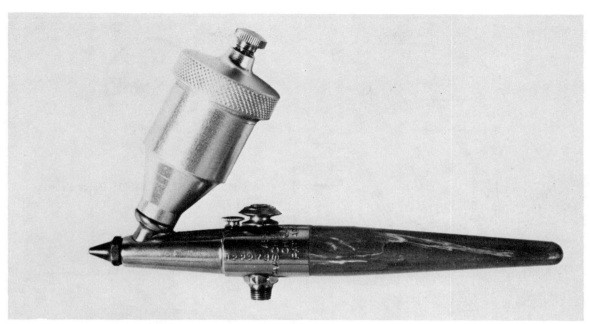

Fig. 2-21. The Paasche AEC-K Air Eraser (courtesy Paasche).

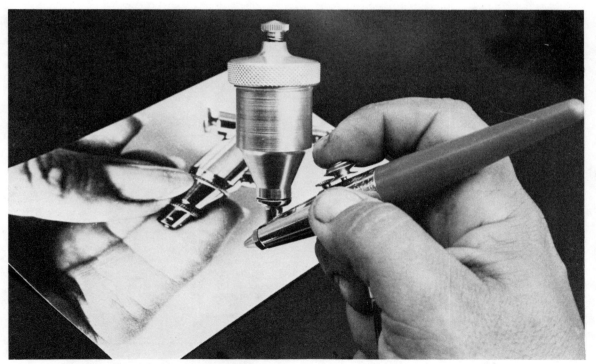

Fig. 2-22. The air eraser applied in retouching artwork.

15

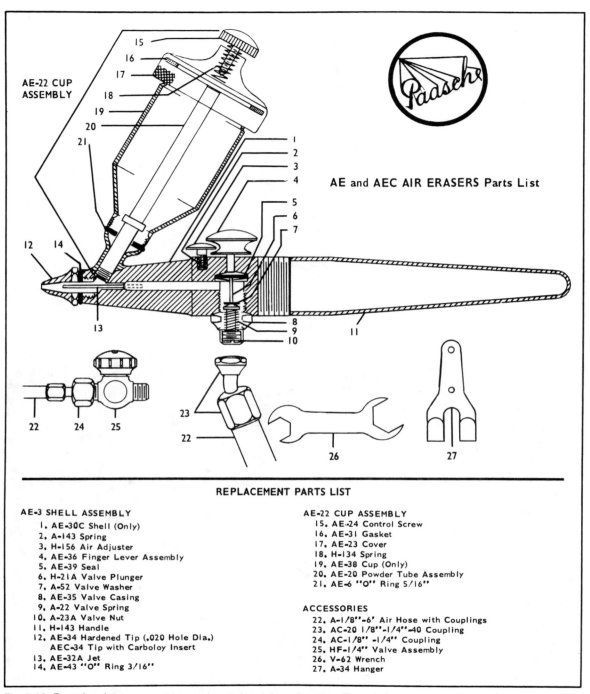

AE-22 CUP ASSEMBLY

AE and AEC AIR ERASERS Parts List

REPLACEMENT PARTS LIST

AE-3 SHELL ASSEMBLY
1. AE-30C Shell (Only)
2. A-143 Spring
3. H-156 Air Adjuster
4. AE-36 Finger Lever Assembly
5. AE-39 Seal
6. H-21A Valve Plunger
7. A-52 Valve Washer
8. AE-35 Valve Casing
9. A-22 Valve Spring
10. A-23A Valve Nut
11. H-143 Handle
12. AE-34 Hardened Tip (.020 Hole Dia.)
 AEC-34 Tip with Carboloy Insert
13. AE-32A Jet
14. AE-43 "O" Ring 3/16"

AE-22 CUP ASSEMBLY
15. AE-24 Control Screw
16. AE-31 Gasket
17. AE-23 Cover
18. H-134 Spring
19. AE-38 Cup (Only)
20. AE-20 Powder Tube Assembly
21. AE-6 "O" Ring 5/16"

ACCESSORIES
22. A-1/8"-6' Air Hose with Couplings
23. AC-20 1/8"-1/4"-40 Coupling
24. AC-1/8" -1/4" Coupling
25. HF-1/4" Valve Assembly
26. V-62 Wrench
27. A-34 Hanger

Fig. 2-23. Paasche air eraser anatomy and parts breakdown (courtesy Paasche).

some may have preferred features. I venture to make this statement, however: all the airbrushes on the market today will perform the function for which they were designed. Some of them (the better designed and usually the most costly) do offer the most versatility combined with ease of operation. The final decision must remain in the hands of the prospective buyer.

As a professional artist, writer, and craftsman, I find it most difficult to rely on any one airbrush to fulfill all my vocational, hobby, and craft needs. With my deep involvement in testing and evaluating airbrushes and airbrushing techniques, I have tested and operated virtually all of the airbrushes on the market today. This experience has expanded my outlook on the mechanics of airbrushing.

For all of my work, I rely on a roster of six airbrushes and one air eraser. All are "exercised" and used regularly; some excel over others in specific situations. However, I would never advocate that you buy a stable of half-a-dozen airbrushes: the cost involved would be prohibitive and none but the dyed-in-the-wool professional would be able to use such an extensive roster. I find that the most serious enthusiasts own at least two airbrushes—one for fine work, one for general applications.

Having said this, I will offer some recommendations that will assist you in proper and valid selection of your first or second (if you already own a basic airbrush unit and wish to upgrade your performance with the inclusion of more versatile equipment) airbrush.

Single-Action Airbrushes

For the beginner or first-time buyer, the very basic *external-mix, nonadjustable* models offer a means of airbrushing at a minimal cost. At best, these very basic units are a formidable step above the aerosol spray can that most laymen are familiar with. These "baby" spray units are limited to large-area spraying and are not very controllable. They are best suited for spraying models (planes, boats, and so forth), coloring scenic model landscape, spraying clear coats and varnishes over

wood and decoupage pieces, and applying ceramic glaze.

Moving up to improved but still basic units, there are the more flexible and variable *single-action, external-mix adjustable* models (Fig. 2-24). These are siphon-feed types and use bottom-feed paint receptacles (cups or 1- to 2-ounce jars). Spray width may be moderately controlled and these upgraded models are relatively easy to adjust, disassemble, and service. These simple but adequate models are also moderately priced, and therefore infringe minimally on the average budget.

Next in line, and a big step up in versatility, capability, and quality, are the *single-action, external-setting* units with *internal* needle paint metering. Two classic examples of this airbrush version are the Badger 200 (Fig. 2-25) and the Thayer and Chandler Model E. The Badger 200 is a very good airbrush and the best buy in its class in terms of excellence and versatility. Though paint metering is regulated by an external setting knob at the rear of the handle—a minor drawback overridden by the 200's capabilities—this unit can effectively handle fine rendering as well as general

Fig. 2-24. The Badger 350, a typical single-action, external-mix unit.

Fig. 2-25. Single-action, internal-mix Badger 200.

work. The Badger 200 offers two options or needles. By switching needles and heads, the 200 may be set up to do extra-fine work or average rendering. To add to its versatility, the 200 can be used with a special paint cup, a 1- or 2-ounce paint jar.

Double-Action Airbrushes

Professionals, fine artists, and discerning airbrush enthusiasts will opt for the top-of-the-line airbrushes with the greatest flexibility: the superior *double-action, internal-mix* offerings with many units of this type; the most reliable makes, in my opinion, are the Badger, Paasche, and Iwata. The top-of-the-line versions produced by these manufacturers are infinitely adjustable and have excellent broad to fine line characteristics. Their working mechanisms are also superior to those of their competitors. They seldom break down; simplified servicing can be undertaken by the owner, and parts are readily available (particularly with the Badger line, since this brand can be found in virtually all the better art and hobby supply shops).

Keep in mind that these exclusive double-action airbrushes are refined, delicate instruments so they must be used with select, specially ground, or thin pigment mediums.

Another top-of-the-line airbrush is the Paasche AB, mentioned separately here because its operation is distinctly different from that of its double-action contemporaries. This is the only double-action model that does not base its operational characteristics on the Bernoulli principle. This airbrush, conceived for critically fine line rendering, is explored in detail in the section on specialty airbrushes.

Two new airbrushes by Iwata (Figs. 2-26 and 2-27) feature bottom bottle feed. A nice feature of all Iwata airbrushes is the quick disconnect joint (Fig. 2-28) for multi-brush use, which makes it possible to quickly change an airhose to various airbrushes during the course of a job.

AVAILABLE AIRBRUSHES

The best criteria for selection when considering the purchase of an airbrush is personal trial and experimentation. Before you buy an airbrush try it on for size, so to speak. Get the feel of the instrument and its mechanical controls. See how comfortably it fits in your hand, preferably with a filled paint receptacle and hose attached. Check the fingertip reach and the action of the activating lever. Don't be influenced by brand names, another individual's preference, or an impressive price tag. A more expensive model is not necessarily better, though the superior units tend to be more costly. The airbrush you finally select and purchase should be tailored to your own specific requirements.

Following is a compilation of virtually all the currently available airbrushes listed in their structural and operational categories.

Single-Action, External-Mix, Siphon, Nonadjustable
 Badger 250-4 Mini Spray Gun
Single-Action, External-Mix, Siphon, Adjustable
 Badger Model 350
 Binks Model 59
 Paasche Model F-1
 Paasche Model H
 Paasche Model HS
Single-Action, Internal-Mix (Needle), Siphon, Adjustable

Fig. 2-26. Iwata's HP-BC, patterned after the HP-C model, accept a variety of pigment materials. The bottom-feed system facilitates quick changes of large quantities of pigments, a nice feature for professionals who do repetitive work.

Badger Model 200
Thayer and Chandler E
Wold K
Wold J

Double-Action, Internal-Mix, Siphon, Adjustable
Badger Model 150
DeVilbiss Model ABA-606
Grafo Type IIC

Iwata HP-BC (Fig. 2-26)
Iwata HP-BE (Fig. 2-27)
Paasche Model VL
Paasche Model VLS (Fig. 2-29)
Thayer and Chandler Model C
Wold W9
Wold A-2N

Double-Action, Internal-Mix, Gravity-Feed (Top Cup), Adjustable
Badger Model 100 GXF
DeVilbiss Model ABA-609
DeVilbiss Super 63E
Efbe Illustrator B1
Holbein Y-2
Holbein Y-3
Iwata HP-A (Fig. 2-30)
Iwata HP-B (Fig. 2-31)
Iwata HP-C
Iwata HP-E
Paasche VJR (Fig. 2-32)

Double-Action, Internal-Mix, Gravity-Feed (Side Cup), Adjustable
Badger 100
Binks Model 59-200 Raven
Efbe Industrial B2
Efbe Hobbyist B1
Grafo Type 3
Holbein Neo-Hohmi
Iwata HP-SB
Paasche Model V
Paasche Model AB
Thayer and Chandler Model AA
Thayer and Chandler Model A
Thayer and Chandler Model B
Wold A-1
Wold A-2
Wold Master

Special-Category Airbrush Types
Badger Model 400
Paasche "AEC" Air Eraser
Paasche FP Flow Pencil
Paasche AUTF Spray Gun
Sata Decorating Gun

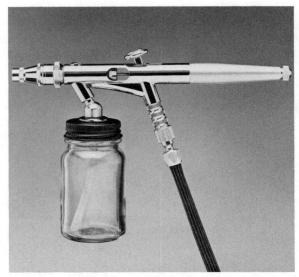

Fig. 2-27. Iwata's HP-BE siphon-feed airbrush is patterned after the gravity feed HP-E, but with the added feature of bottle feed. This heavy-duty, general-purpose airbrush will spray a medium-to-broad pattern suitable for fabric art, posters, custom painting, and other general spraying needs.

Fig. 2-28. Iwata's miniature quick disconnect joint for multibrush user's automatically shuts off the air when disconnected, making it a valuable feature for artists using an expensive CO_2 air source.

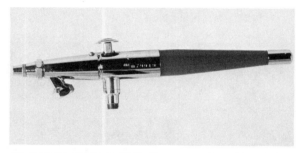

Fig. 2-29. The Paasche VLS will accommodate a host of color cups in various sizes and will handle most pigments and thinned lacquers (courtesy Paasche).

Fig. 2-30. The Iwata HP-A contains an internal paint reservoir in the upper part of the body (courtesy Iwata).

Fig. 2-31. The Iwata HP-B with integrated top gravity-feed cup (courtesy Iwata).

Fig. 2-32. Another top cup model; the Paasche VJR (courtesy Paasche).

Chapter 3

Air Supply

Once you have selected an airbrush, you must consider the air supply since no airbrush, no matter how select, can operate without this "heart" of the system.

There are basically three methods of air supply preferred by artists and operators for airpainting:

1. Compressed air tank
2. Electric motor operated compressor with continuous air flow (usually a diaphram type)
3. Electric motor operated compressor with reserve tank (usually a piston type)

COMPRESSED AIR TANKS

Compressed air tanks offer a very primitive means of air supply, so obviously they are not a favored choice for providing air (Fig. 3-1). Although the compressed air tank is the quietest form of air supply, it is not fully reliable: it is prone to pressure drops in prolonged use and is limited in air supply. The carbonic (CO_2) tank must be filled regularly from a source usually a distance from the studio or art rendering locale.

Aerosol cans are still worse and are promoted only by hobby shops, which can realize a quicker turnover in propellant cans than in compressors since the former are cheaper at the onset (but more expensive in the long run). A good compressor is a far better investment; even the cheaper and cruder compressors offer far more than compressed air cans or bottled air sources.

COMPRESSOR DESIGNS

Two basic compressor designs have made their mark and are most applicable for airbrushing: the diaphragm type and the piston type.

Diaphragm Compressors

Diaphragm compressors, inaugurated many years ago, are still used and preferred by many airbrushers. They are minimal maintenance units and are professed to produce a nonpulsing, even spray. This is especially evident in the better-designed, costlier types; most of the cheaper units tend to pulse and overheat since they must run

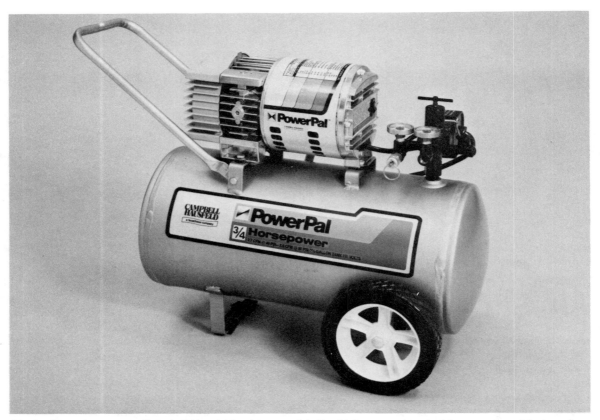

Fig. 3-1. The ¾ horsepower Campbell-Hausfeld tank type model offers higher pressure output, has a reserve air tank, and can run a number of airbrushes at the same time.

continuously and rapidly to keep up with the air pressure requirements. The cheaper models also tend to "walk," and noisily at that. The better, costlier diaphragm compressors are self-bleeding (a requirement that allows excess built-up air to escape while the airbrush is not operating). This built-in feature is necessary because it insures against the compressor's overheating, stalling, and possibly breaking down. Diaphragm compressors should not be run continuously; cooling-off periods are necessary in order to prolong compressor life.

Two noteworthy diaphragm compressors that enjoy much popularity in the airbrushing field are the Badger Model 180-1 (Fig. 3-2) and the Paasche D-1/10 PA (Fig. 3-3). A second version of the Badger Model 180-1 the 180-2, features an automatic shutoff valve that activates the compressor as

Fig. 3-2. The Badger Model 180-1.

Fig. 3-3. The Paasche D-1/10 PA (courtesy Paasche).

the airbrush trigger is depressed. When the trigger is released and the airbrush is laid at rest, the compressor automatically shuts off. This practical feature keeps the compressor from running continuously. Other diaphragm compressors are illustrated in Figs. 3-4 and 3-5.

Piston-Action Compressors

The second type of compressor uses a piston action for creating air pressure and is considered a more reliable air source. It is less prone to "pulsing" and usually capable of generating more air pressure than the diaphragm type.

A revolutionary new type of piston-operated compressor has recently been released and is manufactured by Thomas Industries in Sheboygan, Wisconsin. Thomas calls this new piston concept the WOB-L and it is destined to become the choice

Fig. 3-4. The diaphragm type Campbell-Hausfeld Power Pal has a full ½ horsepower motor, is reasonably priced, and includes a color-coded pressure adjustment knob for selecting air pressures.

23

Fig. 3-5. The Paasche D-¼hp oilless diaphragm type compressor with "studio quiet" operation.

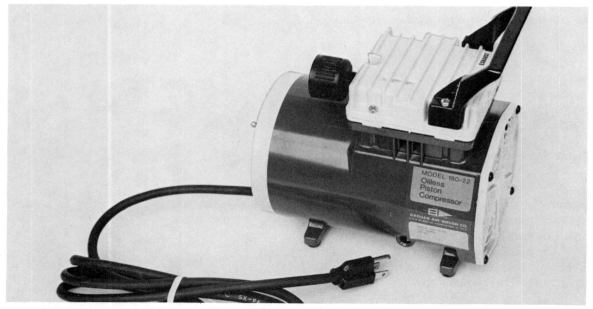

Fig. 3-6. The Badger 180-22 is based on the new WOB-L principle.

PISTON TYPE COMPRESSOR
BADGER MODELS
180-22 & 180-22E

Maintenance Instructions
Before proceeding with any maintenance, remove electric cord from outlet.

REPLACING A CONNECTING ROD ASSEMBLY

Remove the six head screws (Key No. 18) to remove the head (Key No. 29). Then remove the valve plate (Key No. 28). Remove four front cover screws (Key No. 16) and remove front cover. Remove fan (Key No. 3) by pulling outward. Loosen set screws (Key No. 19) and (Key No. 17) and pull out eccentric (Key No. 4). Rod can be removed thru head section of housing. When reassembling be sure "O" Ring seal (Key No. 14) is properly seated in groove and valve screw is over pocket in valve plate.

REPLACING THE INTAKE VALVE

Remove the six head screws (Key No. 18) to remove the head (Key No. 29). Remove the valve plate (Key No. 28) and turn plate over. Remove screw (Key No. 20) and keeper (Key No. 12). Replace flapper (Key No. 13) and reassemble.

REPLACING THE EXHAUST VALVE

Remove the six head screws (Key No. 18) to remove the head (Key No. 29). Remove screw (Key No. 20) and keeper (Key No. 12). Replace flapper (Key No. 13) and reassemble.

REPLACING THE AIR SEALS

Remove the six head screws (Key No. 18) to remove the head (Key No. 29). Remove seal (Key No. 24) and replace taking care not to damage seal surfaces. If seal (Key No. 14) needs replacing, remove valve plate (Key No. 28) and replace seal. Reassemble.

REPLACING ECCENTRIC & BEARING ASSEMBLY

Remove the four front cover screws, front cover and fan. By using a long 1/8" socket head set screw wrench, loosen the socket head set screw in the eccentric by going thru the port hole in side of housing. To loosen the connecting rod, use a long 5/32" socket head wrench on screw on lower end of rod. After this is completed, the eccentric can be removed by twisting from side to side slightly. To reassemble, reverse procedure. When tightening the connecting rod screw be sure not to over-tighten. Approximately 15 to 20 inch lbs. are required and is sufficient. The eccentric set screw is to be tightened to 75 inch lbs.

All other services for maintenance on this unit cannot be made in the field and must be made at the factory.

Key	Part No.	Description	Qty.	Key	Part No.	Description	Qty.	Key	Part No.	Description	Qty.
1	602684	Shft., Rtr., & Brg. Assy.	1	17	625114	Screw - Connecting Rod	1	33	605002	Grounding - Screw	1
2	607093	Connecting Rod Assy.	1	18	625207	Screw - Head	4	34	626328	Grounding - Nut	1
3	633572	Fan Assembly	1	19	625244	Set Screw - Eccentric	1	35	626329	Washer - Ground	1
4	645572	Eccentric & Bearing Assy.	1	20	625307	Screw - Valve Flapper	2	36	657473	Nameplate (Not Shown)	1
5	607034	Insulated Connector	3	21	625329	Screw - Stator	2	37	607002	Hose Connector	1
6	608108	Stator (115V, 60 HZ)	1	22	633328	Cord	1	38	614551	Bearing Cover	1
7	614519	Motor End Cap	1	23	633222	Strain Relief	1	39	625332	Screw - Handle	2
8	614464	Front Cover	1	24	633629	"O" Ring Gasket - Head	1	40	626509	Lockwasher - Stator	2
9	615468	Piston Sleeve	1	25	634022	Tyrap Tie (Not Shown)	1	41	629113	Handle	1
10	615469	Spacer - Eccentric	1	26	646124	Ball Bearing - Hsg. & M.E.C.	2			**Model 180-22E**	
11	602489	Switch (Off-On)	1	27	624244	Rubber Bumpers	4	Delete:		Add:	
12	617045	Valve Keeper Strip	2	28	657162	Valve Plate	1	608108		Stator	608424
13	621102	Valve Flapper	2	29	660626	Head	1	657473		Nameplate	657474
14	623539	"O" Ring Sleeve	1	30	660926	Housing	1	657162		Valve Plate	657531
15	625330	Screw - Motor End Cap	2	31	634530	Exhaust Decal (Not Shown)	1	607002		Hose Connection	—
16	625331	Screw - Front Cover	4	32	660573	Filter Assembly	1				

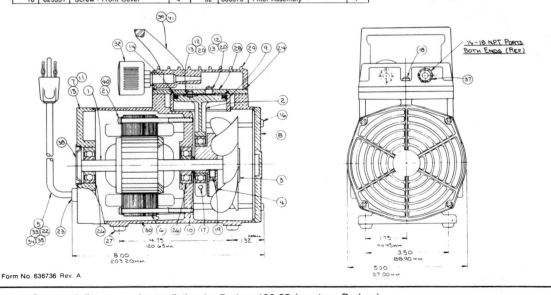

Form No. 636736 Rev. A

Fig. 3-7. Structural diagram and parts listing for Badger 180-22 (courtesy Badger).

Fig. 3-8. Another heavy-duty WOB-L type unit: the Badger 180-24.

delivering more cubic feet of air per minute at a given pressure. Internal features that make the WOB-L compressor virtually maintenance-free are: short stroke and piston diameter; no ring or wrist pin to wear out; a flexible seal that expands with use to maintain sealing properties; and Teflon-impregnated, hard-coated aluminum alloy cylinders. A number of these WOB-L type compressors are available from Thomas. All are ideally suited to airbrush operation.

Two other WOB-L principle type compressors are marketed by Badger Airbrush Company. The most popular is the 180-22 (Figs. 3-6 and 3-7) capable of delivering .8 cfm at 40 pounds psi and .43 cfm at 80 psi.

A more efficient and powerful unit also following the WOB-L principle is the Badger 180-4, which is able to provide enough pressure to power six airbrushes. The versatility and capabilities of the WOB-L type compressors more than compensate for their cost, which is usually higher than contemporary piston, compressors. The Badger 180-24 with similar power as the 180-4 has in addition a reserve tank for building up pressure for using multiple airbrushes.

Although not mandatory, I would advise adding a good air regulator and water trap to the compressor air-feed system. Air regulators and water traps are discussed in Chapter 4.

maintenance-free, lifetime compressor on the market and a boon to airbrushers. The WOB-L compressor is not only very quiet, due to internal muffling in the head design, but it is also capable of

Chapter 4

Airbrush Attachments And Accessories

There are a number of attachments and accessories made for airbrushes or for use in conjunction with airbrushing systems. Some are necessary and desirable, some are just novelties. This chapter presents and describes what are considered the necessary or select additions.

WATER TRAPS

Water traps or extractors are of primary importance. Sooner or later the insertion of some water-preventive device will be mandatory since condensation forms in all compressors, especially over prolonged periods of operation. This condensation builds up and eventually travels down the line. When it reaches the airbrush it will: spit through the nozzle, breaking up proper atomization; and intermingle with the paint, throwing off its atomized mixture or consistency (if the water coincides with a paint media of a base not compatible with water, you have added problems). The bottom line is that this forced condensation can ruin a piece of artwork or the craft or hobby piece being rendered.

Water traps may be purchased integrated with regulators and gauges or separately. All that is necessary is a simple extractor such as the Norgren Type F07. This miniature filter is described in detail in Fig. 4-1.

In operation, air from the compressor first enters the inlet and fills the reservoir and then exits out an opening opposite the inlet. Water entering the trap with the pressurized air will drop into the reservoir since it cannot bridge the gap between the inlet and the outlet. A release button when pressed allows the water to blow out of the reservoir cup. The reservoir cup should be drained frequently and water should not be permitted to build up in it.

Extractors can be mounted at the compressor or, even better, halfway between compressor and airbrush, preferably at a higher level than the compressor (see Chapter 3, Air Supply). Figure 4-2 shows the Badger 50-051 Water Trap, which in this installation is placed after the air gauge.

Another form of water filtration (not as effective as the water trap) is the *in-line filter,* which is hooked up in the same manner as the gas filter on an

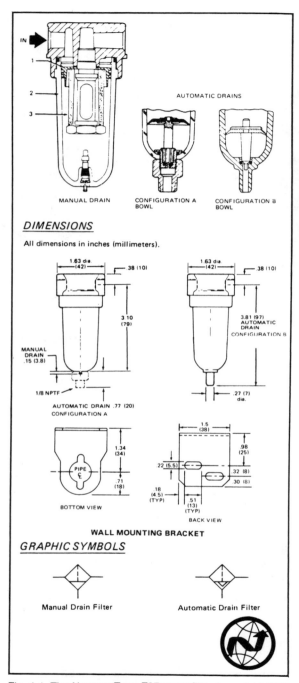

MANUAL DRAIN CONFIGURATION A CONFIGURATION B
 BOWL BOWL

DIMENSIONS

All dimensions in inches (millimeters).

1.63 dia. (42) .38 (10)
1.63 dia. (42) .38 (10)

3.10 (79)
3.81 (97) AUTOMATIC DRAIN CONFIGURATION B

MANUAL DRAIN .15 (3.8)
1/8 NPTF
AUTOMATIC DRAIN .77 (20) CONFIGURATION A

.27 (7) dia.

1.34 (34)
.71 (18)
PIPE ₡
BOTTOM VIEW

1.5 (38)
.98 (25)
22 (5.5)
.32 (8)
.30 (8)
.18 (4.5) (TYP)
.51 (13) (TYP)
BACK VIEW

WALL MOUNTING BRACKET

GRAPHIC SYMBOLS

Manual Drain Filter Automatic Drain Filter

Fig. 4-1. The Norgren Type F07 water filter (copyright 1981 by C.A. Norgren Co.)

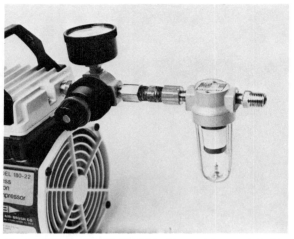

Fig. 4-2. This Badger 50-051 Water Trap unit is mounted after the air gauge.

automobile. The in-line filter (Fig. 4-3) is plastic (or metal) and contains an absorbing filter drum that entraps water traversing through the lines. This filter mounts "in-line" on the airbrush hose (Fig. 4-4) and is far less expensive than the water trap. The use of two in-line filters in a common hose will further increase water absorption.

AIR REGULATORS

Most basic airbrush compressors maintain the necessary fixed output of air to properly operate the airbrush, so an air regulator may not be a crucial necessity. It is, however, exceedingly useful, especially in instances where lesser pressures may be desired for special or "trick" effects. The air regulator should, therefore, be an integral part of your air supply system.

Figure 4-5 shows an air regulator gauge

Fig. 4-3. A Badger in-line filter.

Fig. 4-4. The in-line water filter is mounted on an airbrush hose.

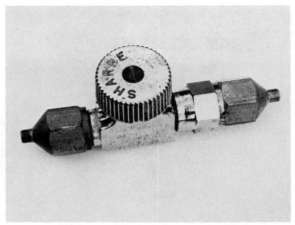

Fig. 4-6. The Sharpe air regulator is efficient and inexpensive.

mounted in its proper place on the compressor. The gauge is a luxury. After a short while most airbrushers find that they do not have to revert to one to obtain proper working pressures; they can set pressure by instinct and by the feel of the air pressure emanating from the airbrush nozzle when the air button is depressed.

A great air regulator or pressure-reducing alternative is the unit shown in Fig. 4-6. It is a Sharpe spray gun regulator, which may be obtained at automotive paint supply stores. With a reducing fitting, it can be used with narrower airbrush hoses. It works magnificently and costs only $8.00 to $10.00,

half the price of a decent regulator. Binks also makes a similar air reduction valve.

HOSE CONNECTORS AND ADAPTERS

Virtually all airbrush manufacturers produce their own hoses with adapters for use with their own and with competitive types. Right-angle junctions, multiple airbrush mounting fittings, and others are readily available. Figures 4-7, 4-8, and 4-9 show some of these adapters.

CUPS, JARS, AND PAINT RECEPTACLES

All airbrushes and airbrush kits contain some

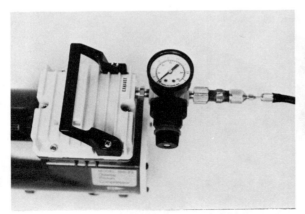

Fig. 4-5. The air regulator gauge is mounted on the exhaust orifice.

Fig. 4-7. Coupling units (courtesy Paasche).

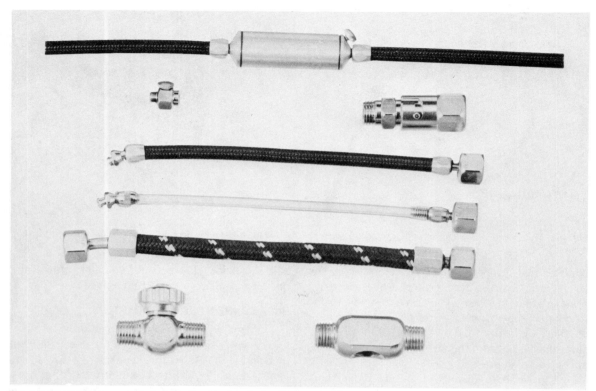

Fig. 4-8. Paasche accessories include (from top) an in-line filter, a needle valve, a compressor-to-hose adapter, three types of hoses with end fittings, three-way tee, and an air valve (courtesy Paasche).

Fig. 4-9. Iwata airbrush adapters for existing hose-type connections (courtesy Iwata).

Fig. 4-10. Two sizes of paint cups are offered by Iwata. The larger unit features a screw-on cover (courtesy Iwata).

Fig. 4-11. The wide array of Paasche paint receptacles available (courtesy Paasche).

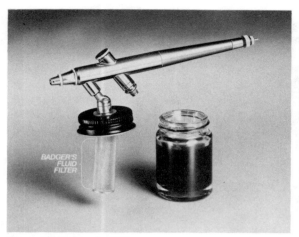

Fig. 4-12. Badger fluid filter.

Fig. 4-13. The fine wire mesh filter element by Badger is most efficient for filtering pigments and sediment.

form of paint receptacle. Some airbrushes sport the small side cup units, some a variety of jars in from 1- to 3-ounce sizes. In addition to the standard side cups that come with the airbrush, some companies offer larger cups designed to fit in the same access hole. The larger cups sometimes come in handy: they offer larger paint volume and need to be filled less frequently (Fig. 4-10).

A number of airbrushes, like the Paasche VL-5, Paasche H, Badger 150, and Badger 200, will adapt to the many 1- to 3-ounce jars that are marketed. The better high-volume jars are the ones marketed by Paasche; they are easy to slip on and off and contain wide, metal feeder tubes that are easy to clean and not prone to clogging. The wide array of Paasche cups (Fig. 4-11) can be used with a number of airbrushes manufactured by other companies, a boon to airbrushers.

PAINT FILTERS

Recently, the Badger Airbrush Company introduced the Badger fluid filter, which can be placed in any of their 1- or 2-ounce jars and will fit many of the similar jars produced by the manufacturers (Figs. 4-12 and 4-13). This filter fits on the shank of the siphon tube and is highly effective in filtering out pigment coagulants and undissolved particles. These filters are very efficient, highly recommended, and a necessity to the serious airbrush artist.

Chapter 5

Setting Up the Airbrush

Setting up an airbrushing facility is a simple operation. For optimum operating conditions some do's and don'ts are in order, and the discussion that follows will ensure proper preparation and installation.

THE COMPRESSOR

First, you must be sure you have all the proper elements: hose, airbrush, adapters (if necessary), and, of course, the compressor.

The compressor should be set up to be out of the way and at the lowest point, which is usually the floor. If the compressor tends to vibrate excessively or walk, you should place a foam rubber pad (about ½-inch thick) under it. This will keep the machine in place and assist in deadening noise and vibration.

The majority of airbrush compressors have ½-inch threaded outlets. Most air hoses come with the proper adapter for these outlets on one end. If the threaded outlet is male, you need only screw on the ½-inch nut end of the hose; if the outlet is female, a ½-inch thread section (about 1 inch long) will have to be inserted in order to secure the hose. The ½-inch thread fitting can be found in all hardware stores.

If you are using a compressor with high output (over 30 pounds), you should attach an air regulator. This unit (see Chapter 4) is best attached directly to the compressor, the hose consecutively attached to the air regulator. Many airbrush compressors give off a standard 20 to 25 pounds of pressure; a regulator is not mandatory for these air supply units but is handy if you wish to get certain special effects that may require lower pound-pressure outputs.

THE WATER TRAP AND FILTER

Water traps and water filters are a must because all compressors generate condensation, which is easily transmitted along the air lines. Condensation (or water) when intermingled with some paints will cause adverse reactions in airbrush spray, particularly if the paints are not compatible with water. If you place a water trap (which is the best unit for water extraction) in the system, insert it about halfway between the compressor and the

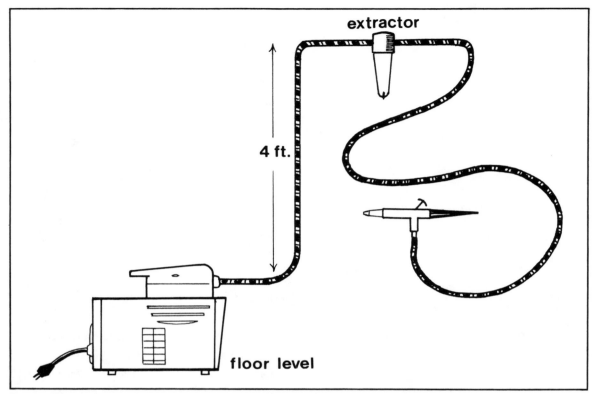

extractor

4 ft.

floor level

Fig. 5-1. The ideal way to set up an airbrush and compressor for foolproof operation.

airbrush, and higher (about 4 feet) than the compressor. This placement makes it more difficult for water to traverse the line since it must fight gravity as it works its way up. If water does work its way up, it will be contained by the water trap, which is easily emptied by depressing a built-in release valve.

If you want to use an in-line water filter, a secondary choice, it can easily be inserted into the line about three-quarters of the way from the compressor. In-line filters are cheaper than water traps but are not as effective. They are, however, better than nothing and should be used. Some people use both in a system, further guaranteeing water-free airbrushing. Figure 5-1 shows an ideal and proper airbrushing system.

AIRBRUSH HOSES

Airbrush hoses come in varying lengths; the

most common are the 10-foot versions assembled ready for use, with proper fittings attached. Each airbrush company manufactures hoses compatible with its own airbrushes and a few offer adapter units for different systems. A rule of thumb with hoses is to keep them as short as possible for the best performance possible. If you can use a hose shorter than 10 feet, by all means do so.

THE AIR VALVE

The end of the hose opposite the compressor attaches to the airbrush, usually with a small, nut-like fitting. This is rotated onto the threaded endpiece at the bottom of the airbrush. This airbrush bottom extrusion is also the housing for the airbrush's air valve, which controls the flow of air into the airbrush. The valve must be in good working order and can be tested by pressing down the activator button (without paint in the airbrush paint

Fig. 5-2. Small-necked polyethylene bottles are ideal for paint and thinner storage and for transmitting paint to paint cups. Always label solvent bottles so you know what is contained in them.

receptacle). If you can feel the air through the airbrush nozzle, the air valve is providing air flow. If no air comes out of the orifice, the valve may be defective or the hose fitting not properly seated. Also check to see that there are no air leaks (which can be felt or heard) at the airbrush-hose junction.

THE AIRBRUSH

Airbrushes in most cases are ready to use out of the box. For some unit, like the Iwata, you must properly seat the needle, since they are shipped with the fluid needle partially retracted. Properly positioning the needle is a simple matter. Remove the handle, loosen the needle chuck nut, move the needle forward (but not tightly) into the nozzle, and finger tighten the chuck nut. Make sure the spray regulator tip is properly adjusted (usually screwed all the way in). If the regulator tip is not properly seated or adjusted, you will get an erratic spray or none at all, with air feeding back into the paint cup.

THE PAINT RECEPTACLE

With all these prerequisites taken care of, the next step is to fill the paint receptacle with paint. If you are using bottom-feed jars, fill them up with paint and firmly screw on the caps. One jar filled with water or whatever solvent is appropriate for the paint used should also be kept on hand. This solvent jar is used to intermittently flush and clean the airbrush to free it of pigment residue buildup throughout use.

If the airbrush selected provides a side cup-feed, the cup should be firmly but not tightly seated into the proper location. Do not fill the cup until you are ready to airbrush.

The best way to store and administer paint into a side cup is by means of 6-ounce polyethylene bottles, which can be obtained at most art supply stores (Fig. 5-2). These squeezable bottles are useful for filling and metering small amounts of paint into airbrush cups (or any airbrush paint receptacle, for that matter) with no fuss and no muss.

Chapter 6

Maintenance

Maintenance is a secondary factor in airbrushing but one that must be practiced diligently if the airbrush is to be kept in proper, foolproof working order.

Day-to-day working maintenance involves running appropriate solvents through the airbrush at regular working intervals, particularly when changing colors, and not allowing paint to dry within the paint cup (jar) or on the needle nozzle and other working mechanisms that are in contact with pigments. You should also check that the needle moves easily and doesn't stick or jam.

After airbrushing for prolonged periods, you should disassemble the airbrush and immerse the parts in a good all-around solvent. A small tin or dish (Fig. 6-1) is good to have on hand for soaking disassembled airbrushes. I find that the best cleaning medium for soaking and cleaning parts is automotive lacquer thinner. Lacquer thinner is a powerful cleaning agent and will dissolve and break down any paint pigment used for airbrushing. It is imperative that you remove all air valves and gas-

kets *before* immersion. These parts can be adversely affected by the potent lacquer thinner.

The air valve, located at the junction of the air hose and airbrush air inlet, contains a solvent-sensitive O ring packing. You should remove this and set it aside; never immerse it in solvents (Fig. 6-2).

With time, air valves will deteriorate and malfunction. It is wise to keep a spare air valve unit on hand at all times (Fig. 6-3). Replacement internal parts for this valve may be obtained, but it is far simpler to replace the entire valve assembly since it is not an expensive item.

The only tools necessary for airbrush disassembly and maintenance are a pair of small long-nose pliers (modeler's type) and a special wrench for head removal (Fig. 6-4). The wrench is almost always supplied with the airbrush and varies, according to different airbrush manufacturers.

Carefully study assembly schematics to familiarize yourself with internal working parts and assembly and disassembly procedures. Replace-

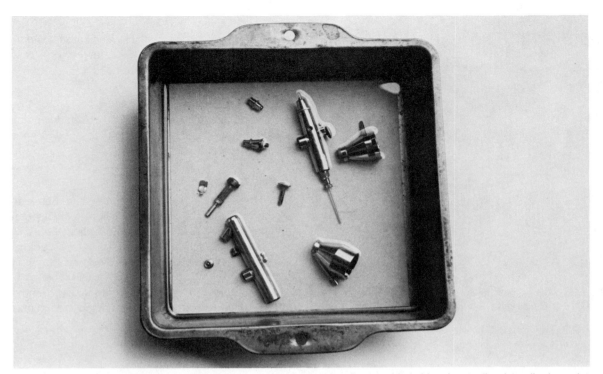

Fig. 6-1. A shallow tin with ½-inch of lacquer thinner is ideal for soaking disassembled airbrushes to dissolve adhering paint and pigment sediment.

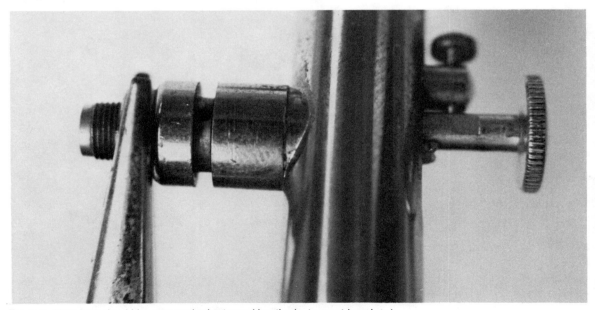

Fig. 6-2. Air valves should be removed prior to soaking the instrument in solvent.

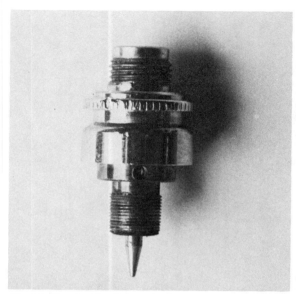

Fig. 6-3. The air valve. Extras should always be kept on hand.

ment parts and breakdown diagrams (Fig. 6-5) are provided for all airbrushes. These diagrams should be kept because they must be referred to in case replacement parts are ever needed.

CLEANING THE AIRBRUSH

Once the airbrush has been broken down and immersed, it should be thoroughly cleaned. A good step-by-step approach follows.

Removing the Needle

This is important! The needle should be handled with utmost care. Here is where most assembly and damage problems manifest themselves.

On single-action needle airbrushes, remove the needle by revolving the spray control knob at the rear of the airbrush (Fig. 6-6), and when it is fully rotated out of the threads, pull it out. Removing the needle also releases the trigger, which may

Fig. 6-4. Basic diassembly tools.

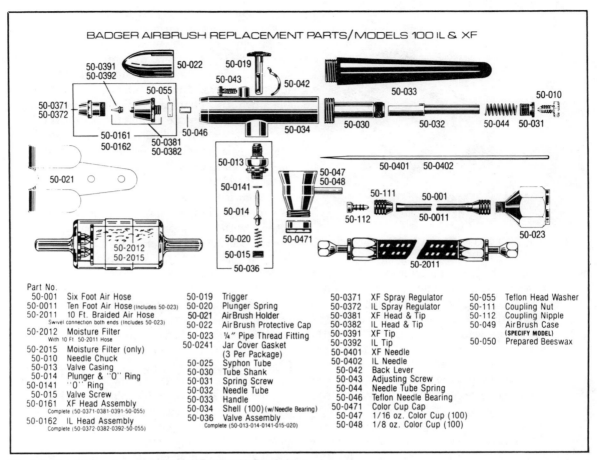

BADGER AIRBRUSH REPLACEMENT PARTS/MODELS 100 IL & XF

Part No.							
50-001	Six Foot Air Hose	50-019	Trigger	50-0371	XF Spray Regulator	50-055	Teflon Head Washer
50-0011	Ten Foot Air Hose (Includes 50-023)	50-020	Plunger Spring	50-0372	IL Spray Regulator	50-111	Coupling Nut
50-2011	10 Ft. Braided Air Hose	50-021	Air Brush Holder	50-0381	XF Head & Tip	50-112	Coupling Nipple
	Swivel connection both ends (Includes 50-023)	50-022	Air Brush Protective Cap	50-0382	IL Head & Tip	50-049	Air Brush Case
50-2012	Moisture Filter	50-023	¼" Pipe Thread Fitting	50-0391	XF Tip		(SPECIFY MODEL)
	With 10 Ft. 50-2011 Hose	50-0241	Jar Cover Gasket	50-0392	IL Tip	50-050	Prepared Beeswax
50-2015	Moisture Filter (only)		(3 Per Package)	50-0401	XF Needle		
50-010	Needle Chuck	50-025	Syphon Tube	50-0402	IL Needle		
50-013	Valve Casing	50-030	Tube Shank	50-042	Back Lever		
50-014	Plunger & "O" Ring	50-031	Spring Screw	50-043	Adjusting Screw		
50-0141	"O" Ring	50-032	Needle Tube	50-044	Needle Tube Spring		
50-015	Valve Screw	50-033	Handle	50-046	Teflon Needle Bearing		
50-0161	XF Head Assembly	50-034	Shell (100) (w/Needle Bearing)	50-0471	Color Cup Cap		
	Complete (50-0371-0381-0391-50-055)	50-036	Valve Assembly	50-047	1/16 oz. Color Cup (100)		
50-0162	IL Head Assembly		Complete (50-013-014-0141-015-020)	50-048	1/8 oz. Color Cup (100)		
	Complete (50-0372-0382-0392-50-055)						

Fig. 6-5. Breakdown diagram (courtesy Badger Air-Brush Inc.).

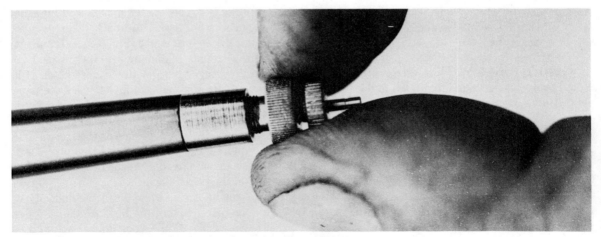

Fig. 6-6. Removing the needle of a single-action, rear-setting airbrush.

Fig. 6-7. Removing the needle of a double-action airbrush.

be pulled out of the body and set aside. The needle should be wiped clean with solvent-laden cotton. If stubborn paint sediment refuses to come off, drawing the needle through a small folded piece of 600 grit sandpaper (using fingertip pressure) will do the trick. Always pull toward the needle tip, stopping about ½ inch before the point. If the point contains sediment, it can be rotated *lightly* over a piece of similar sandpaper; don't apply excessive pressure—a gentle wiping motion will suffice.

To replace the needle, *gently* slip it into the rear of the airbrush after you have reinserted the trigger button. Make sure that the slot in the stem of the trigger button is dead center or the needle tip will be damaged when inserted. The needle should be pushed until it is fully seated in the nozzle. This can be checked by eye.

With double-action airbrushes, the procedure is similar but more complicated because of the added back-and-forth sliding motion of the trigger, typical with all double-action units. This sliding action of the moving needle tube is governed by a back lever that controls tube movement (which in turn, controls back-and-forth action of the needle). Figure 6-5 shows this back lever element (see 50-042).

As the trigger button moves back, so does the back lever in a cantilevered action. The basic problem is the misalignment or loss of the back

lever, since it can easily fall into the airbrush body when the needle and trigger are removed. You can get around this problem easily. Before removing the needle (Figs. 6-6 and 6-7), slide the trigger all the way to the rear until it is butted against the back lever. Then wrap some ¼-inch masking tape around the fully retracted trigger to firmly secure the trigger, applying pressure against the back lever. Now the needle can be pulled out and cleaned. After cleaning, the needle can be reinserted with ease since the tape keeps the trigger and back lever both secured and aligned.

Figure 6-8 shows the tip of the back lever protruding from the top of the airbrush body (see arrow), with the button removed. You can see how the unsecured back lever can easily fall into the body. If this occurs you will have to remove the needle and tube shank (see Fig. 6-5, 50-030) and allow the back lever to fall out through the back of the body. Reinserting this back lever is a major problem and involves time, nimble fingers, and a wealth of patience. The obvious methods of reinsertion involve tweezers and pliers, but unless minute tweezers or jeweler's pliers are on hand, this process could be tedious.

I recently discovered a foolproof method while trying to evolve a back lever reinsertion procedure for this book. Take a piece of business card stock 3 inches long and ½-inch wide. Fold this piece in half lengthwise, which gives you a *V*-shaped strip. Insert one end of the strip into the slot of the back lever. As the *V* expands after it is placed into the slot, it secures and holds the back lever evenly. Next, cock the lever forward (Fig. 6-9) and reinsert it into the airbrush, realigning it in its prospective place in the trigger slot. With the card stock still holding and aligning the back lever, place the trigger back in position and force it back against the back lever with finger pressure, holding the back lever in place. Keeping pressure on the trigger and lever, withdraw the card stock, and then reinsert the tube shank and needle. Secure the needle and you are "all together" again.

The double-action breakdown methods illustrated here take much of the headache out of airbrush disassembly. While your double-action air-

Fig. 6-8. Back lever location.

Fig. 6-9. Reinserting the back lever.

Fig. 6-10. Oiling the needle tube shank.

brush is still disassembled, put a drop of light machine oil on the moving needle tube shank (Fig. 6-10, see arrow) to ensure proper, free-sliding action before replacing the handle.

General Simple Maintenance

Simple general maintenance involves proper cleaning of external parts and paint orifices. The airbrush extrusions that connect to the paint jar or cup should be frequently cleaned since they pick up pigment residue that clings to the internal wall area. On bottom-feed airbrushes, this press-on collar should be swabbed out with a brush or, even better, with a cotton swab, as shown in Fig. 6-11. Airbrushes that have side cups should also have the access orifices cleaned out in a similar manner. If openings are too small to accommodate a cotton swab, a toothpick or wire with cotton rolled onto the tip will do the job nicely; a small, stiff watercolor

brush can also be used to get into these more confined openings.

Cleaning Airbrush Tip (Cap) or Spray Regulator

This small, frontal, screw-on segment of the airbrush tends to build up paint residue quite readily and frequently. This residue buildup may be cleaned out using a solvent-laden brush or cotton swab. In cases where the excess pigment refuses to dislodge itself, it can be removed by scraping the point of a #11 X-Acto blade over the inner surface of the tip (Fig. 6-12).

Cleaning the Head

The airbrush head is one complete unit situated at the frontmost section of the spray tool and usually consists of three integrated parts: the cap or spray regulator, the head piece, and the

Fig. 6-11. Cleaning the jar collar.

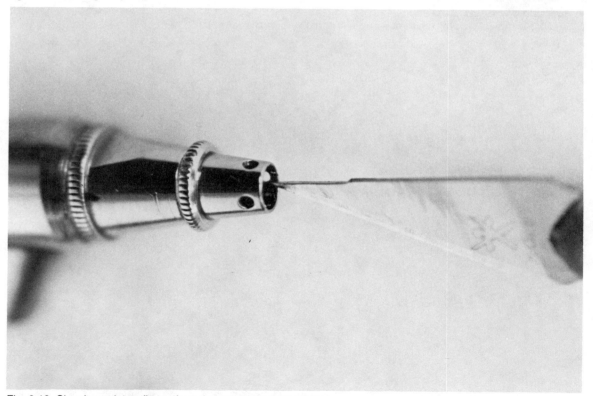

Fig. 6-12. Cleaning paint sediment from the spray cap or regulator.

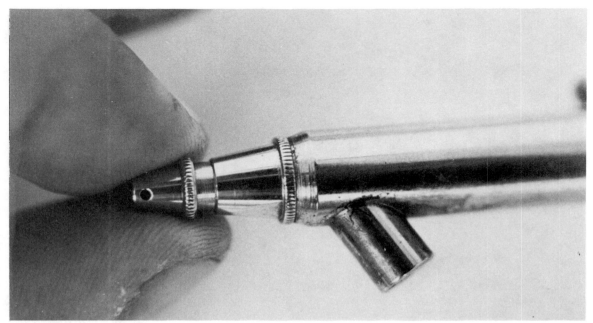
Fig. 6-13. Removing the spray regulator.

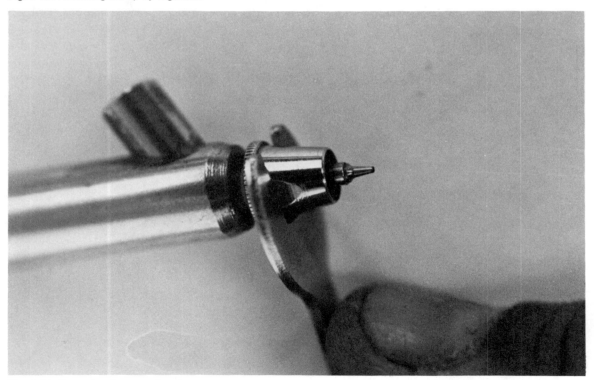
Fig. 6-14. Removing the spray head.

44

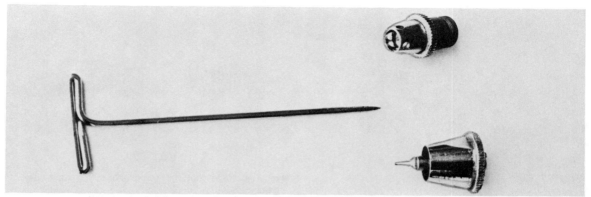

Fig. 6-15. The T-pin makes an ideal reamer for cap and nozzle.

needle nozzle, all contained together by means of screw threads.

The head removes easily, but care must be exercised here since the parts are delicate and can be easily damaged. First remove the spray regulator. This piece should be removed and tightened back on by hand pressure—but not too tightly. If the tip is too tightly inserted or holds fast, you can use the small pliers to dislodge it. Don't clamp down too tightly with the pliers either, because if you do, you will damage the knurled grasping ring around the tip. Proper tip removal is shown in Fig. 6-13.

The head unit or its integrated parts may be removed with the needle in or out of the airbrush. If the needle is left in, the point will be exposed when the head is removed, so exercise caution or you will damage the point. To remove the head body, use the wrench supplied with the airbrush (Fig. 6-14).

The needle nozzle should not be removed, if possible, since it can be cleaned while affixed to the head. If by some chance you *must* remove the needle nozzle (for replacement if damaged, or if paint

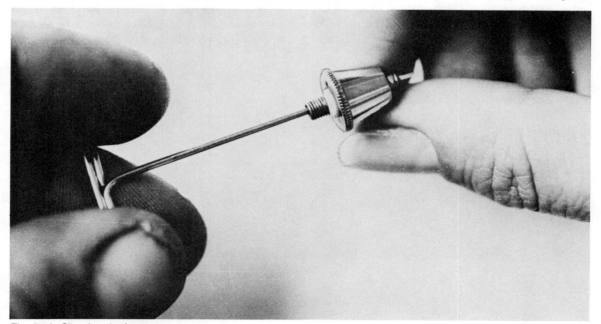

Fig. 6-16. Cleaning the head and nozzle.

Fig. 6-17. Rear of spray head.

Fig. 6-18. Paint cups with removable bottoms are easier to clean.

coagulates within, blocking the orifice), do so with the mini pliers, using the thin plier tips for grasping.

The best and most practical way to clean the orifices of the integrated head components is by means of a T-pin (Fig. 6-15), which is used as a reamer. Insert it into the rear of the head and push in until it stops; then rotate it until all pigment residue is dislodged (Fig. 6-16).

Figure 6-17 shows the back of a typical airbrush head. All the openings should be checked frequently for paint buildup and thoroughly cleaned out with the T-pin. When attaching the head back onto the body of the airbrush, make sure the air seal is in place. Some airbrushes use an O ring or Teflon seal or washer; some use beeswax, which should be liberally applied around the circumference of the rear face of the head.

CLEANING PAINT CUPS AND JARS

Jars should be cleaned out with rags and immersed in solvent; the metal connecting and siphoning tubes should be swabbed out with solvent-laden pipe cleaners.

Side cups should be immersed in solvent and also their tubes should be cleaned with pipe cleaners. Some cups (Fig. 6-18) have removable bottoms that should be screwed off, giving access to the suction holes in the bottom of the cup body. Paint builds up in these holes, and they should be cleaned out regularly with the tip of a pin.

Chapter 7

Troubleshooting

I have stressed maintenance and cleaning throughout this book, because it is very important to keep the airbrush in good, trouble-free working order. Occasionally, however, there may be operational problems that the airbrusher may not be familiar with or know how to keep under control. Note that when the airbrush is atomizing and spraying properly, it should emit an even, steady spray—you will get to recognize it easily (Fig. 7-1).

PROBLEMS AND SOLUTIONS

Following is a list of problems you may encounter, descriptions of their symptoms, and solutions for circumventing each.

No Spray Emission

This can be caused by a number of things: the nozzle is too distant from the air supply; the spray regulator is screwed out too far; the paint is too viscous; the breather hole in the color jar is blocked; the nozzle is pigment-blocked; the needle chuck is loose so the needle does not retract when you slide back the trigger; the lever assembly is broken; or the air valve is broken. Most of these problems may be remedied by simple adjustment or cleaning. In the case of a faulty air valve, discard it and replace it with·a new one.

Spatter or Spitting

This too can be a common occurrence (Fig. 7-2, top), promulgated by the following: the air pressure is not in proper relationship to the fluid supply; there is dirt (dried paint, etc.), in the nozzle; or the air feed is clogged. Check to see if any of the above are present, then remedy the situation. If there is dirt or dried paint in the nozzle, disassemble the head and immerse and cleanse the component parts in a good solvent (lacquer thinner).

Spattering with the spray pattern emitting at an angle means that you have a bent needle or a cracked nozzle. In both instances, replace with new parts. Keep in mind that spattering can also occur if there is water or foreign matter in the air hose.

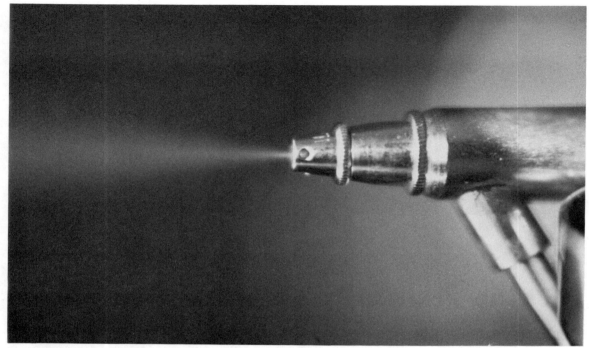

Fig. 7-1. Proper air spray pattern (needle at wide open setting).

No Air at Airbrush Tip

This is usually caused by a broken or defective air valve. Repair or replace it. Also check the air compressor to be sure it is pushing out air.

Grainy Spray

This is caused by a too-heavy paint solution. Check the paint-to-liquid ratio as well as the air-to-paint ratio. If you have the proper paint-solvent

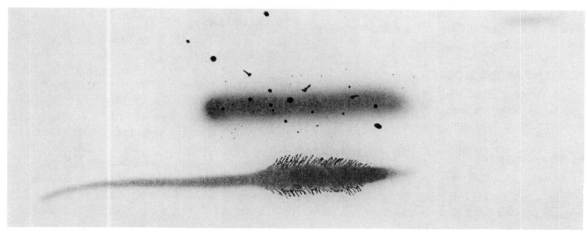

Fig. 7-2. (Top) spattering pattern; (bottom) centipedes.

mixing solution, you should get a proper spray pattern and density with 25 to 30 pounds air pressure at the airbrush.

Flared Ends (Each End of Stroke)

This occurs when the spray starts before the hand starts its side movement and stops before the paint flow is terminated. Practice even stroking.

Spidering or Centipedes

This occurs when too much paint is released too closely to the paper (Fig. 7-2, bottom). Practice proper air-paint blending with the trigger.

Restricted Spray Pattern

This will occur if the spray regulator is screwed too far into the head. Revolve it out a few turns until the problem is remedied.

Bubbling

This is air feedback in the color cup or jar. It is caused by revolving the spray regulator out too far. Turn it in until bubbling stops. Bubbles will also form in the cup if the color cup stem becomes clogged.

Pulsing Spray

This can be caused by a pulsing air supply (impotent compressor), dirt in the nozzle, an improperly seated nozzle or nozzle cup, or a worn nozzle washer. The problem can be solved by instituting a more positive air supply source, properly seating the nozzle and cap, or replacing a worn nozzle washer.

Blowups

These will occur if paint does not atomize properly or if the airbrush is held too closely to the surface. This can also happen if paint is overly thinned (Fig. 7-3).

AIRBRUSH SETTING AND TUNING

The airbrush should be frequently set and

Fig. 7-3. Blowups.

tuned to avoid problems. The following should help you carry this out properly.

The Needle

When reinserting a needle, tighten the needle chuck firmly enough to grip the needle but not so tightly that it impedes back-and-forth travel; this should be done by instinct and familiarization with needle chuck manipulation.

The Lever

The lever should also be set and tuned frequently. The lever spring should be tensioned so that the lever springs backward and forward gently. If the lever snaps back when released in its rearward position, the spring should be readjusted.

The Air Valve

The air valve spring (which controls up-and-down lever action, releasing and cutting off air) should be set in such a way that when finger pressure is removed, the lever returns easily and smoothly. If up-and-down movement is erratic or inhibited, the air valve spring is either badly tensioned, kinked, or jammed. Also check the air valve spring retainer to make sure it is not screwed in too tightly.

After Tuning

When operating the airbrush after tuning, make sure that plain air comes through before the needle moves back. Make sure the needle tip is properly seated and aligned in the nozzle. A properly tuned airbrush will ensure proper operation.

Chapter 8

Airbrush Paints

There's an old adage about paint and airbrushes: "If it can be thinned down enough, it can be sprayed through an airbrush." There's some validity to this statement. Any thin liquid will traverse through an airbrush, but we must give some thought to what the condition of the airbrush after spraying will be; how extensive and rapid a cleanup is necessary; and how the pigment mediums affect the internal workings and channels of the airbrush.

PAINT TYPES

Choices of paints and pigments that can be used for airbrushing are wide and varied; the type selected should be governed by the project involved. Paints vary in density and consistency, so I will also give suggestions on how to arrive at proper pigment-to-solvent ratios.

Photo retouching dyes are not universal media (they cannot be used for painting, for example) and are therefore covered separately in Chapter 17.

Shellacs and Glazes

Shellacs have minimal application to airbrushing. They are used to prepare and seal raw woods and are also used in decoupage. More commonly, they are brushed on, but airbrush or spray application guarantees even coating and control.

Shellac is a thin medium in stock form; it requires no more than a one-to-one thinning ratio between the medium and its solvent, which is alcohol. All wood shellacs and spar varnishes are prepared in this manner and my advise is to use them with heavy-duty airbrushes.

Alcohol should be flushed through the airbrush between sprayings to insure against "tacky" shellac buildups on the internal surfaces and orifices of the airbrush.

Clear enamels (glazes) should be thinned three-to-one (one to three parts turpentine or mineral spirits to one part glaze, the proper solvent for clear enamels).

Printing Inks

These inks are adaptable for airbrushing T-shirts and for general painting on paper and illustration board. Their popularity is waning, however, because specific airbrush dyes and paints that are superior and more versatile for identical applications have recently been formulated. Printing inks are water soluble; since these inks are very viscous in nature, a good mixing ratio is one part ink to three to four parts water.

Flo-Quil and Model Railroad Flat Lacquers

These flat lacquers are ideally suited for painting metal surfaces (Fig. 8-1). They have a moderate consistency and need minimal thinning. One part lacquer to one part thinner gives a proper atomizing mix. Since Flo-Quil lacquers use a specific thinning agent (Dio-Sol), it is recommended that only this agent be used for diluting.

Poly-S

Poly-S is another paint medium specifically formulated for painting models and miniatures. It is manufactured by Flo-Quil, but unlike Flo-Quil lacquer, Poly-S lacquer is water-based rather than solvent-based. It is excellent for spraying on plastic surfaces and applies well through an airbrush. Poly-S works well thinned one part Poly-S to one part water. It can be sprayed straight from the bottle when used with heavy-duty airbrushes.

Fig. 8-1. Railroad flats are matte lacquers specially designed for painting metal and wood.

Fig. 8-2. Pelikan's Plaka is an excellent airbrushable poster paint.

Model Enamels and Military Flats

Primarily used for final finishes on boats, planes, and trains, these coloring mediums (brand names include Testor's, Humbrol and Pactra) are ideally suited for airbrushing. Each company produces its own specified thinning agent, but these enamels may also be universally thinned with turpentine. Recommended thinning ratios are one part color agent to two parts thinner. They should not be sprayed at too low an air pressure or at too close a distance because they tend to run.

Caseins

Casein paints (sometimes referred to as poster paints) are available in jars or tubes (Figs. 8-2 and 8-3); they are moderately fast-drying, milk-based tints and are water soluble. Although caseins are not very popular with contemporary airbrushers, their use should not be minimized since they can be used with an airbrush to achieve distinctive effects. The proper thinning ratio is one part casein to four parts water. Frequent cleaning should be practiced throughout use since this medium is highly coagulable, affixing itself quickly and firmly to delicate working parts and orifices of the airbrush.

Pelikan brand Plaka casein paints are the most superior caseins available; they are opaque and

Fig. 8-3. Pelikan designers' colors can be airbrushed easily when thinned down.

waterproof after 24 hours. Plaka must be well diluted and mixed since it has a tendency to settle at the bottom of the jar or cup. Plaka is highly concentrated and has great covering power.

Gouache Paints

Gouache paints are highly favored by fine artists. Since they are comprised of refined, finely ground pigments, they are very desirable for airbrushing. The better gouache offerings are from Winsor Newton and Grumbacher.

Gouaches are water soluble and fast drying. The proper thinning ratio is one part gouache pigment to four to five parts water. Prior to use, gouaches must be well and vigorously mixed until thoroughly liquid for the best airbrush rendering consistency. Constant flushing of the airbrush with water is recommended with gouache paints. After use, the airbrush should be stripped down and thoroughly cleaned.

Tubed Acrylics

The newest paint medium perfected within the last decade, tubed acrylics are favored by fine artists who have found them comparable to oil paints with the exception that they are faster drying than oils. Although they are popular with many airbrush artists, I can't wholeheartedly recommend this medium for airbrushing; there are equivalent mediums that provide identical results and have fewer prohibitive factors.

If acrylics are used, they must be well thinned and well mixed with water. The airbrush must be constantly cleaned and flushed throughout use because this heavily coagulable medium tends to block up and clog an airbrush more than any others do (with the exception of toluene-based automotive

acrylic lacquers, which are heavy in plastic content). A one-to-five paint to thinner ratio is strongly advised and best suited for airbrushing.

Enamels

Oil-based enamels (household type) may be airbrushed but their use is not recommended because they are slow drying. Oil paints may be classified the same as enamels. When thinned down, they have the same properties as enamel. Enamels do not strike a happy medium with the airbrush. Forget them.

Airplane Dope

Used exclusively for airplanes (flying and static models), dope is fast drying and will airbrush well. Larger, heavier-duty airbrushes are preferable for dope since it too is a highly coagulable medium. Ratios of one part dope to three parts acetone are recommended for thinning.

Acrylic Lacquers (Automotive Type)

Acrylic is the fastest drying of all *paints*; it dries almost instantaneously and to a high-gloss finish upon hitting the surface. These properties plus its high resilience make it the optimum choice for automotive painting and customizing.

Acrylic lacquer can be used by fine artists and illustrators as well. Its extremely quick drying time makes it favorable for multiple stencil overlay work. Acrylic lacquers, their properties, and manipulation are reviewed in depth in Chapter 15.

Inks

Inks and dyes such as Pelikan, Higgins, and Dr. Martin's seem tailor made for fine and efficient airbrush rendering and are considered by many to be the ultimate airbrushing tone mediums (Fig. 8-4). They are available in transparent or opaque versions. No thinning is necessary; the brands mentioned can be used straight from the bottle.

Air Opaques

Air Opaque is the newest, most revolutionary

Fig. 8-4. Pelikan's superior airbrush inks are available singly in 1-ounce jars or in complete sets.

Fig. 8-5. Badger Air Opaques, the newest airbrush-ready acrylics, are universally applicable.

paint to hit the market and was formulated by the Badger Airbrush Company specifically for use in airbrushes (Fig. 8-5). This new universal medium, a water-soluble acrylic type, can be airbrushed onto such surfaces as paper, plastics, acetate, and photographs with equally fine results.

Marketed in 1-ounce bottles and available in 12 colors Badger Air Opaque is airbrush-ready (no thinning required). In using this medium, flush and clean your airbrush during and after use. A special Air Opaque cleaning and flushing agent is also provided by Badger.

Acqua Dye Watercolor

These dyes, manufactured by Chartpak, boast a color roster of 96 dye tones (Fig. 8-6). Water soluble, these are the same dyes used in artist's markers and are ideal for producing artist's comprehensives. A special additive agent is also provided for photo retouching work.

Metallic Paints

Some excellent metallic colors adaptable for airbrushing are also marketed (Fig. 8-7). Metallic paints are gouache-type paints and should be well diluted for airbrush work. Four parts thinning agent to one part paint is suitable for metallic acrylic lacquers or poster colors. Metallic inks, on the other hand, should be used as is.

Versatex

Another excellent water-soluble airbrush coloring medium, Versatex is primarily used for fabric coloring. It is an excellent, quick-drying, colorfast dye that becomes permanent with the application of heat from an iron after art or design work is terminated. Extremely popular for rendering on cottons, especially on T-shirt, Versatex is not permanent when used on rayons, acetates, and other cellulose-based fabrics.

Conceived for hand and brush work, Versatex must be diluted somewhat for airbrushing. A workable thinning ratio is one part Versatex to two parts water. With larger, heavy-duty airbrushes, a working paint-water ratio of one to one is feasible.

Fig. 8-6. Aqua Dye watercolors are ultrafine pigments and are available in a wide variety of colors.

Fig. 8-7. Pelikan metallic paint.

Shivair Colors

With the growth in airbrush popularity, paint manufacturers are beginning to introduce pigments specifically formulated for airbrush use straight from the bottle. Shiva, a prominent paint company, recently introduced Shivair custom airbrush colors in both opaque and transparent pigments. The paints are water soluble and come in 2-ounce bottles with easy-dispensing caps. The colors are nonpermanent but can be made colorfast by overspraying with a special aerosal Shiva medium. Shivairosol, an additive medium, can be sprayed over Shivair to inhibit paint cracking, a prominent negative factor with some airbrush media. Another distinctive Shivair line consists of neutral grays, which are excellent for photo retouching.

Com-Art Colors

Nakoda Air Systems distributes another fine line of sprayable, water soluble, permanent opaque colors called Com-Art Colors. Com-Art airbrush paints come in 16 colors, each packaged in 1-ounce, easy-dispense-cap bottles. Based on a hydro carbon resin formula, these colors are tough and resilient and work well in virtually all airbrushes.

SAFETY PRECAUTIONS

You should be aware that some paint mediums are toxic and hazardous to the eyes, skin, and lungs, so use precautions when working with toxic paints. Also, when airbrushing, do not breathe dusts and oversprays, even in minute portions.

Methyl alcohol used as a solvent in shellacs and varnishes is dangerous if absorbed through the skin. It can cause nervous system damage and blindness.

Acetone (including isopropyl and isobutyl acetates) can produce skin and mucous membrane irritation and nervous system depression. It is used as a solvent in airplane paint.

Petroleum hydrocarbons, solvent bases for many enamels and paints, may produce depression, convulsions, and pulmonary irritation.

Toluene, also known as toluol, is extremely hazardous to the lungs, particularly when atomized vapors are inhaled. It is also known to depress the nervous system and cause bone marrow deterioration. Toluene is found in acrylic automotive lacquers, which should be handled with utmost respect.

When using toxic mediums, it is imperative that you use a protective mask and curtail prolonged skin contact. When immersing an airbrush and its components in these solvents for cleaning, the use of rubber gloves is strongly advised.

An excellent, inexpensive protective toxic vapor mask is available from 3M (Fig. 8-8) and may be obtained from any automotive paint supply store. The mask must be discarded a week after it is removed from its airtight package, however, because contact with air makes it ineffective after the recommended time period.

Fig. 8-8. The 3M toxic vapor mask.

1982 Walthers Catalog & Train Reference Manual Cover. Cover concept by Art Director John Sanhein, designed by assistant Art Director Allen Neuwirth. Airbrush rendering by Milwaukee Artist Santos Paniagua.

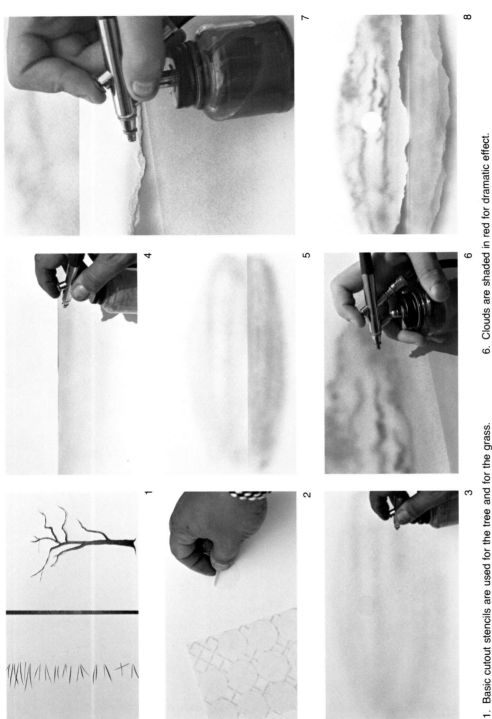

1. Basic cutout stencils are used for the tree and for the grass.
2. A round label (or hand-held bottle cap) is placed on the unpainted mural surface as a mask for the sun.
3. Preliminary cloud effects are airbrushed in.
4. With the aid of a paper or cardboard straightedge, the horizon line is added.
5. Foreground areas are strengthened in red.
6. Clouds are shaded in red for dramatic effect.
7. A piece of paper is randomly torn, and the torn edges serves as a stencil for the background areas and foreground texturing. When the torn edge of the paper is in place, the hills and background are added.
8. The sun mask is removed; the simple scenic effect shown is at about the half-way point.

Photographs 1 through 8, courtesy of Badger Airbrush Co.

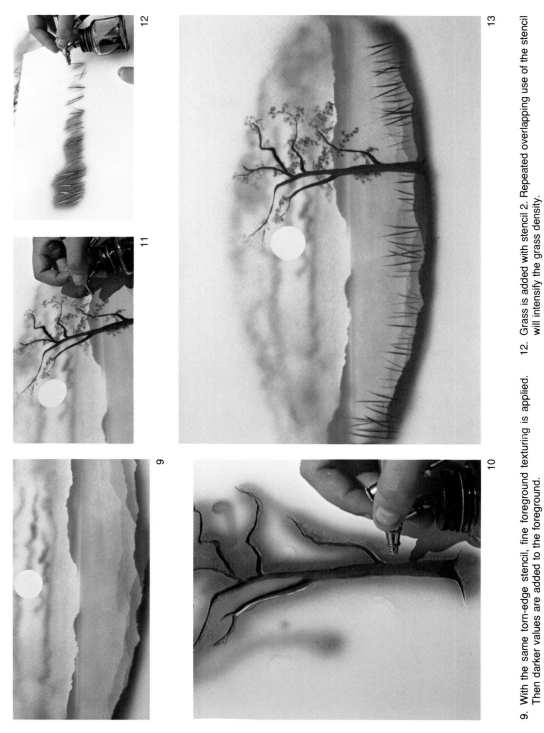

9. With the same torn-edge stencil, fine foreground texturing is applied. Then darker values are added to the foreground.

10. The tree stencil is used.

11. Leaves and foliage are painted freehand using a fine spray setting and short, distinct air bursts.

12. Grass is added with stencil 2. Repeated overlapping use of the stencil will intensify the grass density.

13. The completed mural.

Photographs 9 through 13, courtesy of Badger Airbrush Co.

Motorcycle tank customizing using lace and airbrush. Courtesy Slick Jamieson and Jim Bickford.

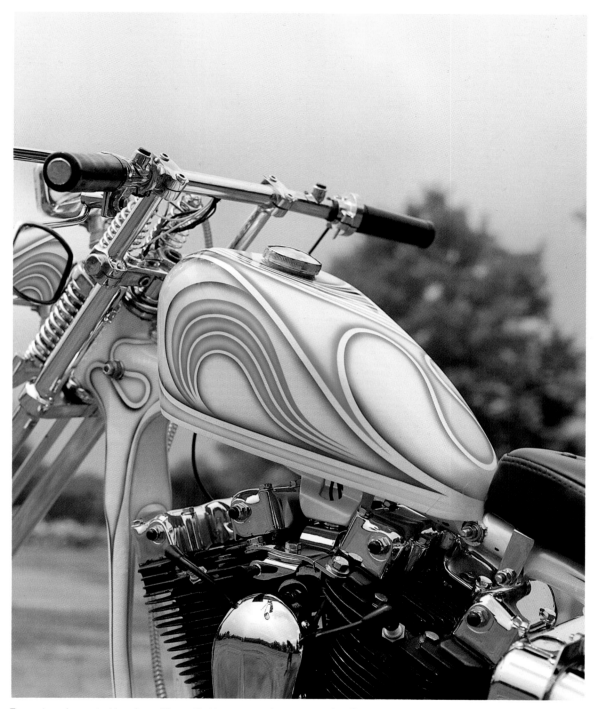

Examples of op art airbrush motifs applied to motorcycle custom paint. Sportster decor by Jack Thomas.

"Painting Through Words" by Jacqueline Metz appeared on the cover of *Seacliff Breeze Magazine*.

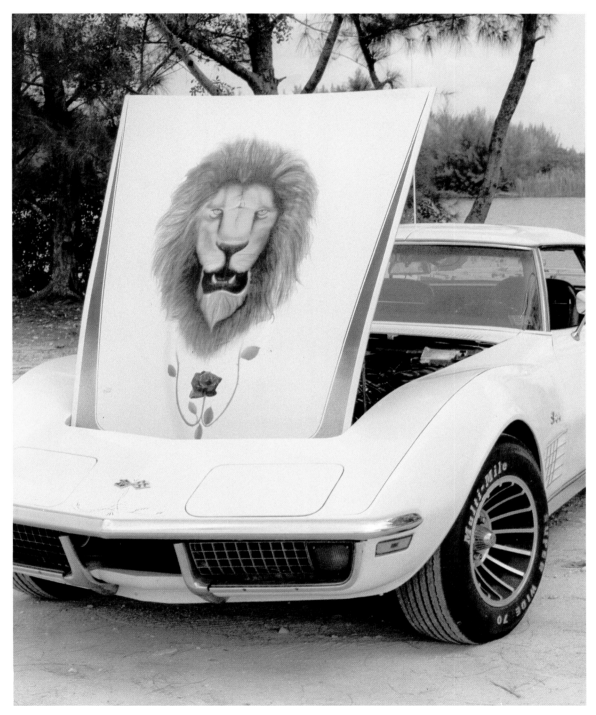

"Lion & Rose," a Corvette mural by Carl Caiati.

Stairway mural by Sliique.

62

Hood corner enhancement on show custom Corvette by Sliique.

Florida airbrush artist Nansea Scoble-Burbulés painting an acrylic-on-canvas seascape.

Queen trigger fish taxidermy study by Nansea Scoble-Burbulés.

"Waterspout at Sea," tube acrylic on canvas by Nansea Scoble-Burbulés.

Freehand rendering of demonic vulture by Chris Seckler, a well-known airbrush fine artist who specializes in freehand rendering of wall murals, fine art, and automotive customizing.

Ford Bronco mural by Carl Caiati.

Tank with airbrush weathering by Ralph Gimenez.

Captain, Charles B. Wright
P-40E Warhawk
16th Fighter Squadron
14th Air Force

Model By - Ed Witlen

P-40E Warhawk with speckled camouflage motif by Ed Witlen.

Airbrushed and weathered diorama by Carl Caiati.

Basic Techniques

After purchase of the airbrush, attaining proficiency with the tool is next in importance. Basic drills and exercises will be of help toward that goal, especially for the beginner. Some of the drills presented here are simple; some, more complicated. Expertise in all of them is important to the serious artist; for casual hobbyists or crafters, basic knowledge and control will suffice. Basic drills are to the airbrusher what scales are to a musician; no matter how proficient you become, returning to and repeating the basic exercises will keep your technique sound and perfect. If you can master these, you will be ready to begin tackling the basic design rendering procedures outlined in Chapters 11 and 12.

HANDLING THE AIRBRUSH

Before beginning the exercises, however, let me review a few points about handling the airbrush: the grip and triggering.

The Airbrush Grip

The best way for you to hold the airbrush is in the way that is most comfortable for you, but there is one widely accepted technique. The airbrush shank is gripped in the same manner as a pen or pencil. Keep in mind that most airbrush bodies are slightly wider in diameter than the standard pencil. (In fact, in some countries the airbrush is referred to as an air pencil.) Most are as wide as a standard pen or, for example the Rapidograph line-drawing pen (approximately ½-inch). The airbrush is butted up against the left side of the middle finger (for the right-handed person) at the first joint. The thumb goes on the side, and the forefinger goes on the top. Whereas in writing or drawing the forefinger remains stationary, with the airbrush it must work up and down to control air flow and back and forth to control fluid flow. (This is true for a double-action airbrush; in a single-action airbrush only an up-and-down movement is necessary).

Airbrushers also use unorthodox variations on this stance: some will trigger with the thumb, some even with the third finger. However, for comfort and practicality, the three-finger grip, with the forefinger working as the activating finger, is the best and most favorable position.

Some airbrushes can be used ambidextrously; some are designed so that the position of the color cup facilitates airbrushing by left-handed technicians. If you are left handed, make sure that when you select your airbrush it is tailored to your specific type of hand manipulation. Specify if you are right or left handed when you are making your purchase.

Triggering

Learning to trigger properly and lay down even tones and lines is the most necessary prerequisite to good airbrushing. To achieve good, steady lines and tones, you must keep the airbrush in controlled, constant motion. To lay a good line or tone you must begin the motion *before* you press the trigger, and you must continue the motion *after* you release the trigger. This will help keep your line constant from start to finish.

Figure 9-1 shows the proper side-to-side motion.

Hold the airbrush tip or point an equal distance from the surface at a 90° angle to the surface from start to finish of the stroke. This may seem simple, but most beginners tend to arc their stroke, making the finished stroke uneven in both density and width. Figure 9-2 shows what is meant by an arcing motion. When you arc, more paint is deposited in the central portion of your stroke than on the ends, causing a paint buildup (Fig. 9-2). Once you have

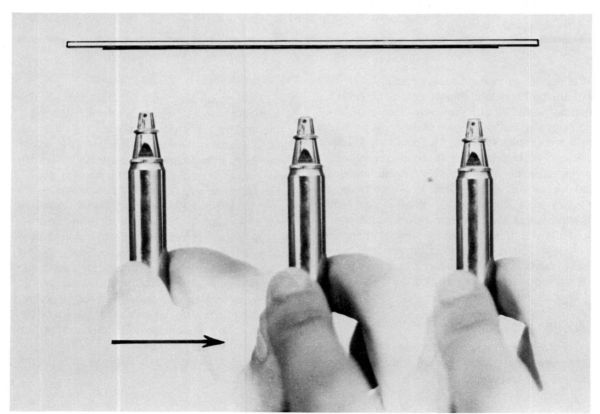

Fig. 9-1. To achieve steady lines and tone, the airbrush should always be kept parallel to the surface.

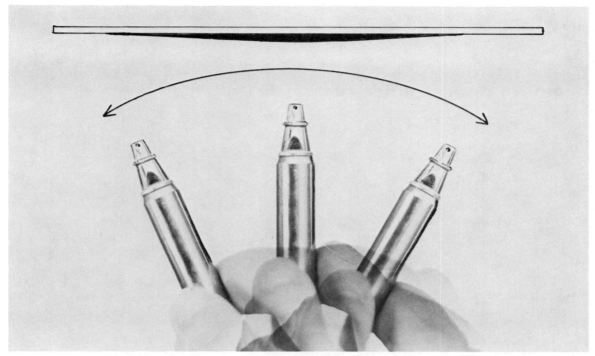

Fig. 9-2. Arcing the stroke causes excessive paint buildup in the middle portion of the line or tone area.

gotten the parallel motion down pat in your head and hand, you can move on to the following drills and exercises.

DOT CONTROL

This simple exercise consists of laying down dots on specified locations. Start with small dots and build up to larger ones. Practice this exercise until you can lay down a series of equal-size dots in a repetitive line and then until you can do this rapidly and at specified points.

On a piece of graph paper lay out a grid as shown in Fig. 9-3. Starting at the upper left-hand corner of the grid, lay on dots. Start with small dots and move progressively to bigger dots as shown. When you can do this exercise with steady control, as in the illustration, you have arrived. Aim first for accuracy; after a while speed will come naturally. Practice with tiny dots first, then move up to bigger ones by allowing more paint to flow while increasing the distance from surface to airbrush tip.

This exercise can be done with both single- and double-action airbrushes; with single-action types, the paint flow must be preadjusted manually before spraying.

THE ATONAL OR FLAT WASH

The atonal or flat wash (Fig. 9-4) is an even, overall toning of a designated area. This is usually accomplished by opening up or fully triggering the airbrush at about 4 inches or more from the surface, depending on the intensity of the tone desired.

To practice this exercise, take a piece of 5-by-8-inch paper. Starting at the top and using an even, parallel motion, tone the paper from left to right. Continue stroking the whole length of the paper from top to bottom, overlapping slightly with each consecutive stroke. The trick is to keep the tonal value even from top to bottom.

The density or darkness of the tone is governed by spray intensity or by paint intensity, which can be modified somewhat by thinning out the pig-

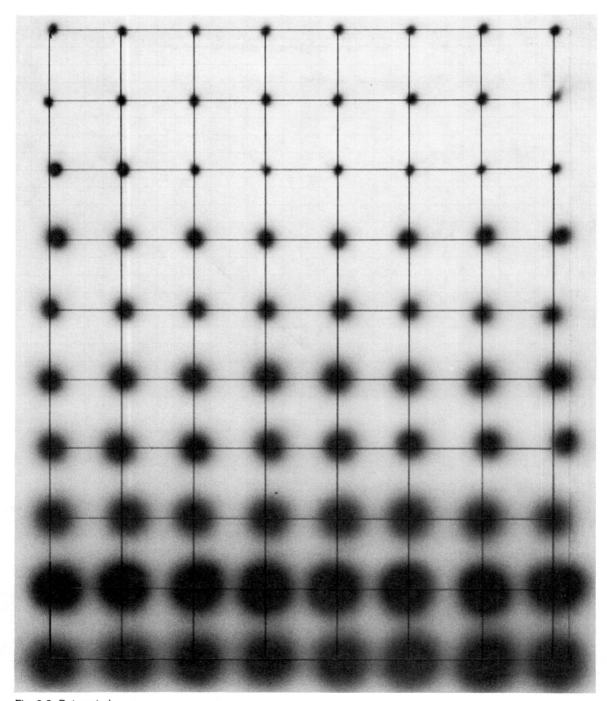

Fig. 9-3. Dot control.

Fig. 9-4. The atonal or flat wash.

Fig. 9-5. The graded wash.

ment. Do not attempt to achieve this effect in one overall application; until you attain proficiency in this exercise, build up the tone gradually by successive overall tonal applications.

THE GRADED WASH

This is closely related to the flat wash, but it builds up tone progressively from light to dark. Start about 2 inches from the top of a 5-by-8-inch piece of paper and begin toning, allowing the first basic tone stroke to fade into the white of the paper. Tone evenly and lightly all the way down the page.

Then about a quarter of the way down from where the initial tone blends into the paper, start a second toning procedure, allowing the second gradation of tone to blend into the first. Repeat this at equal intervals on the paper until you have a progressive gradation of tone from white to dark gray. Figure 9-5 shows a graded wash.

SPOTLIGHTING

This exercise should come fairly easily after you have mastered the flat and graded techniques. Spotlighting is basically a tone gradation exercise.

Fig. 9-6. Spotlighting.

The two basic forms are illustrated in Fig. 9-6. A circular motion replaces the side-to-side motion necessary to lay down the graduating tone.

CONTINUOUS SOFT LINE

In this exercise you run horizontal lines across your practice sheet while trying to keep the lines straight and even. Use a straightedge as a target point to enable you to achieve a tone streak with a sharp edge on one side, a soft edge on the other (Fig. 9-7). Figure 9-8 shows a number of these lines as laid out on the practice sheet. Start out with the thinnest line possible and work up to heavier lines of tone.

Once you have mastered this approach, try laying out identical lines but without the aid of the straightedge (Fig. 9-9). Figure 9-10 shows a finished—and successful—practice sheet.

GRADUATED LINE TONE

This exercise is the most difficult of all in which to attain proficiency. For best results undertake it only with a double-action airbrush. To obtain this effect, you must couple triggering with a gradual angled lifting of the airbrush away from the surface. As you lay down a horizontal spray, pull the

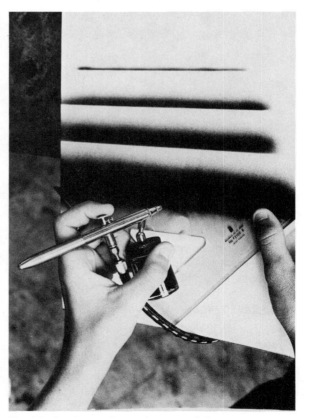

Fig. 9-7. Continuous line and tone rendering.

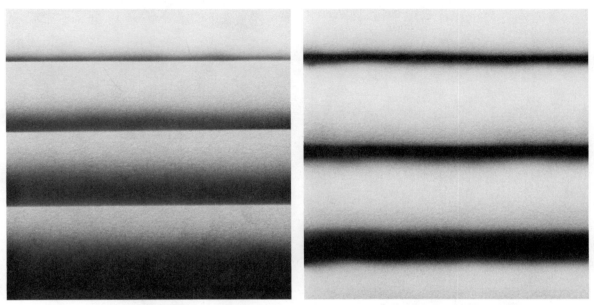

Fig. 9-8. Examples of continuous line and tone rendering.

Fig. 9-10. Examples of freehand tone renderings.

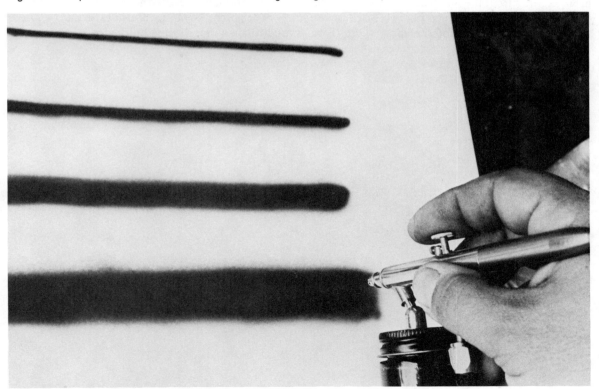

Fig. 9-9. Rendering soft lines and tones freehand.

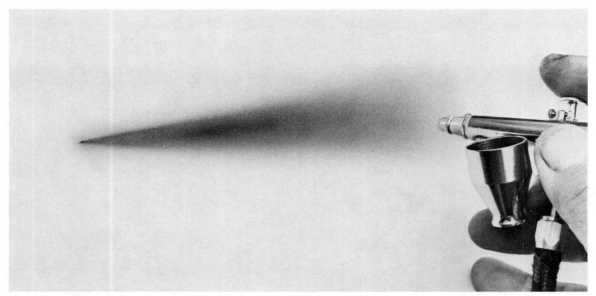

Fig. 9-11. Expanding tone rendering.

airbrush away from the surface in a tangent to the paper while pulling the trigger slowly back to release more fluid and expand the spray width (Fig. 9-11). Coordinating the two actions requires a great deal of practice. Novice airbrushers should be prepared to spend much time on this one.

Masks and Stencils

Masking is a critical and oftentimes necessary aspect of airbrush art and retouching. The mask or masking medium is used both to control overspray and to create hard, sharp edges. Even at most refined settings, the airbrush by itself cannot produce a crisp, sharply defined line or edge.

A mask (or stencil) may be a simple piece of torn paper (see Fig. 16-1) or a highly detailed cutout (Fig. 10-1). There are basically three kinds of mediums that will create hard, sharp edges: stencil mediums (card, paper, or acetate stock), stick-on friskets, and liquid film.

Nonadhesive stencil materials (file stock, waxed paper, and acetate) can be used. Held hard against the surface they create sharp edges; held just off the surface they give soft definition to a cut stencil form.

Choice of masking or stenciling mediums should be governed by which masking procedure best applies to each particular job. Combinations of different masking mediums may also be implemented in order to obtain specialized or varied effects.

STENCIL AND MASKING MEDIUMS

These are only some of the stencil mediums that can be used to create hard, sharp edges.

Masking Tape

Masking tape, a common medium, is best suited for use on plastic, wood, metal, and other slick, nonpulp (paper) mediums. Masking tape is excellent for automotive airbrushed graphics, and the thinner masking tapes (¼ inch and ⅛ inch) can be easily curved for extensive design and line effects.

The best crepe masking tape medium is 3M Scotch Brand automotive grade tape, sold by leading art supply retailers as well as by automotive paint stores. Never use this masking medium for paperbased artwork since the adhesive tends to pick up both surface and under-the-tape artwork, and this will damage the rendering beyond repair.

Wax Stencil Paper

This is an excellent stencil paper; the best

Fig. 10-1. Masks can be hard edged and detailed. Two op art design stencils can be obtained from one cutting. One is a negative stencil (on the sheet) and the cut out piece can serve as a positive stencil.

Fig. 10-2. Waxed paper by Bienfang is excellent for stencils. It is very flexible, inexpensive, and found at all better art supply stores.

Fig. 10-3. Here a tracing is made onto a sheet of waxed stencil paper. The stencil may be cut with an X-Acto knife using a #11 blade.

available is manufactured by Bienfang in rolls and sheets (Figs. 10-2 and 10-3). This paper cuts well and cleanly, making about the best hard edge for rendering stencils. Paint and color are not absorbed because of the waxed surface, hence there is no chance of paint saturating the stencil and possibly transferring through to the artwork.

One word of caution however: don't allow water or other slow-drying paint to build up on the waxed surface because they can run off. Stencils produced from this waxed paper medium should be cleaned or dried off frequently during use.

File Folder Stock

This is about as versatile as waxed paper stock although it does not cut as cleanly or as easily. File folder stock does allow some paint absorption, but since it is thick, there is no eminent danger of pigment print-through. It can be found in stationery and office supply stores. Since it is quick and easy to obtain as well as relatively inexpensive, this stock is highly recommended.

Acetate

Acetate is another very common stencil medium and is used exclusively by airbrush artists. It is easy to cut, offers clean edges, and is tough and resilient. Acetate is the most expensive of the freestanding stencil mediums, but it is also long lasting; stencils made of acetate stock can be used over and over again and they don't tear or damage easily.

Fig. 10-4. Frisket film papers have adhesive backings and may be obtained in sheet or roll form.

STICK-ON FRISKET

This is an improvement over the old airbrush frisket paper. It is a peel-off adhesive-backed plastic film substance that is easy to use and far tougher than the original frisket material (Fig. 10-4). Frisket film is ideally suited to both art rendering and photographic retouching.

Frisket film is transparent and has a soft-peel, low-tack adhesive characteristic. Years ago, before its availability, artists tried to adapt other similar cellulose stick-on mediums, but the results were disastrous: the older adhesives tended to adhere too strongly to the working surfaces, causing damage when removed. In many cases, adhesive deposits would also contaminate the surfaces. The newly designed frisket films adhere well and peel easily, with no damage to the artwork.

Before the frisket is placed over the working surface, you must peel off its protective backing. When you apply the film, take care that no air bubbles or wrinkles occur; if they do, peel the film back to the wrinkle or bubble and reapply it with

Fig. 10-5. Liquid maskoid is applied with a brush, then allowed to dry fully.

Fig. 10-6. When airbrushing is completed, the film is peeled off.

more care, working out the bubbles to the edges of the paper or away from the area to be worked on. When cutting through frisket film, exercise extreme caution, being careful to cut through the masking film but *not* the working surface underneath.

LIQUID FILM

These are used mainly in photo retouching since some of them contain dyes that can be easily absorbed by many common drawing and art papers. The most common of the liquid frisket mediums is photo maskoid. Photo maskoid is applied by brush around the edges of the section to be airbrushed (Fig. 10-5). Do not leave open areas or pinholes since the consecutively sprayed pigment or retouching mediums will bleed or spray through them. After the liquid has dried and and tinting or retouching has been completed, the dried masking medium is peeled off as shown in Fig. 10-6.

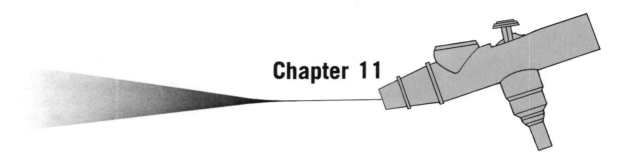

Chapter 11

Op Art Design Motifs

Op art motifs are basic, simplified designs that can be easily achieved with simple stencils or odds and ends serving as design masking mediums. Some of the studies and approaches illustrated in this chapter will be perfectly suited for beginning airbrushers since they are exceedingly simple to execute and will provide the neophyte with a sense of artistic accomplishment.

Many of the studies here are basic op art rendering procedures that are particularly favored by automobile and motorcycle paint customizers. (You will see varying renditions of these op art exercises in Chapter 15.)

DESIGNING WITHOUT STENCILS AND MASKS

Many design patterns can be instituted using the airbrush alone, without stencils.

Blowups

Blowups are circular patterns created by a steady deposit of paint until the paint loses its spray characteristic and expands to a full circle (Fig. 7-3).

Practice with the airbrush and varied degrees of paint dilution until you can obtain perfect, controlled circles with ease.

The airbrush must be very close to the surface to create blowups. Patterns may be built up using different color and overlay combinations (Fig. 11-1).

Freak Drops

Freak drops are basically blowups carried a step further. To create a freak drop effect, dilute the paint considerably and allow the edges of the circle to flare out into a sunburst effect (Figs. 11-2 and 11-3). With double-action airbrushes, you can intensify the spreading, tentacle effect. First apply the paint quickly, and before it has dried concentrate a blast of air into the center of the paint mass. Administer the air blast with the lever or trigger of the airbrush full forward so that only air emanates from the nozzle.

Experimenting with different pigment dilutions and varied airburst pressures will provide a

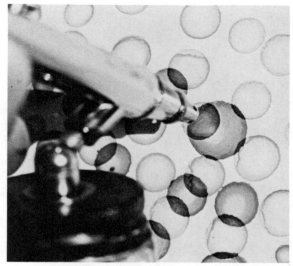

Fig. 11-1. Blowups overlayed in different colors create interesting designs.

Fig. 11-2. Freak drops are basically blowups carried a step further.

range of different freak drop effects. Fast-drying paints, particularly lacquers, are great for freak drop and blowup effects, especially when the designs are to be overlayed one over another.

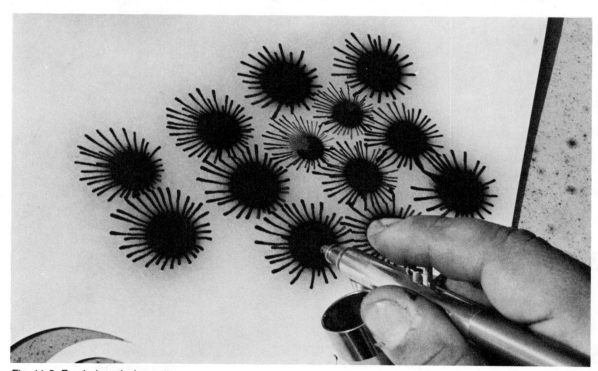

Fig. 11-3. Freak drop design patterns.

Fig. 11-4. The air collage.

Air Collage

Air collage is probably the simplest, most primitive form of airpainting and is executed with the double-action airbrush. Blast the paint on at random, then allow free-flowing air to blow the still-wet paint over the surface irregularly.

Different colors are used in a buildup procedure. Continue building up until you have a design similar in style to the one in Fig. 11-4.

Cobwebbing

Cobwebbing can only be achieved with quick-dry lacquers. In cobwebbing, underdiluted lacquer (more paint, less thinner) is forced out of the airbrush in its heavy viscous state. It deposits itself in strings and cobweblike particles on the surface in a

Fig. 11-5. The cobwebbing effect is achieved by airbrushing thick lacquer through the airbrush.

Fig. 11-6. A completed fish scale panel.

semidry state (Fig. 11-5). The minute hairline pattern looks like a spider's web, hence the term "cobwebbing." Some interesting effects can be achieved using combinations of color and varied paint thinner combinations.

DESIGNING WITH STENCILS AND MASKS

The following effects are achieved using the airbrush in conjunction with stencils and masks.

Fish Scaling

Originally labeled "quilting," this op art motif has been dubbed *fish scaling* because the finished results look like fish scales (Fig. 11-6). The technique is said to be Oriental in origin.

First, make a special mask in which circles are aligned along a straightedge, as shown in Fig. 11-7. The best circles to use for this are the stick-on labe¹ type available at office supply outlets. Place the tabs edge-to-edge until a scallop pattern stencil is assembled.

Lay the stencil on the surface to be rendered and blow an edge fog along the edge as illustrated in Fig. 11-8. Repeat the procedure in the second line of scallops, but offset the mask so that the center of each hemisphere touches the point of the preceding line (Fig. 11-9). Continue this pattern buildup until you get the desired effect or coverage.

An even different effect can be attained using a point or diamond pattern instead of a semicircular one.

Fig. 11-7. The fish scale mask.

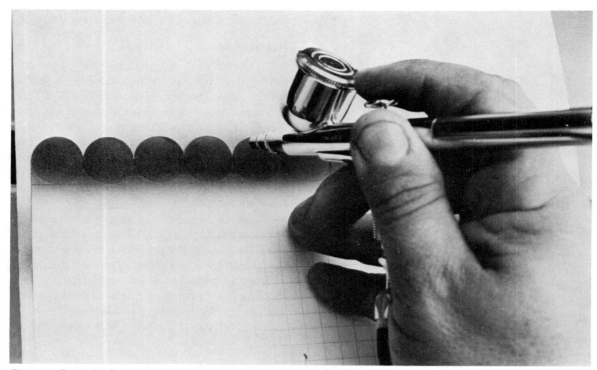

Fig. 11-8. Begin the fish scale pattern by spraying along the edge of the mask.

Fig. 11-9. Offset the second layer and each consecutive one.

Fig. 11-10. A plastic fern leaf is used as a design mask.

Fig. 11-11. A graffiti pattern being created with a draftsman's stencil.

Fig. 11-12. The ornate edging of a French curve used repetitively creates a continuous design pattern.

Different commecially available objects may be used as design stencils. Figure 11-10 shows a plastic fern leaf being used as a design mask.

Drafting and Art Stencils

The commercially available stencils used by artists and draftsmen can be intelligently used for making designs. Figure 11-11 illustrates how a simple stencil was used to lay out a graffito-like collage pattern. Figure 11-12 illustrates the repetitive use of a French curve stencil to create an artistic pattern.

Cellular Overlays

Figures 11-13 through 11-17 demonstrate a how-to sequence of a novel, cellular overlay design pattern that is extremely easy to execute. The masking elements are square stick-on tabs that can be found in stationery or office supply stores. Lay the initial pattern out with the labels as shown in Fig. 11-13. Then lay on an overall tone wash (Fig. 11-14); following this, remove the masking labels (Fig. 11-15) so that you can remask for the secondary overlay. In an offset pattern, a second masking is done in a similar way to the first one, but with the labels on the second layer overlapping the original pattern structure. For the second spraying, you can use an atonal spray wash as before or you can vary it for added effect (Fig. 11-16). You can also use variations in color. Figure 11-17 shows a typical cellular overlay design motif.

Fig. 11-13. Labels are laid out like bricks.

Fig. 11-14. An overall wash is evenly applied.

Fig. 11-16. After the second offset placement of stick-on labels, the overlay pattern is applied. It may be applied evenly as before or with varied gradation and coloration.

Fig. 11-15. The pattern after the squares are peeled off.

Fig. 11-17. A completed cellular overlay pattern.

Lace Painting

This type of design is so named because the finished product emulates lace and also because lace is the stencil medium. For optimum results, use fast-drying paint mediums. Pull the lace serving as a stencil tautly across the surface to be painted. The closer the lace is to the surface, the more finely defined the end result.

Some precautions should be taken when spraying through lace. Spray lightly, allowing the color to build up with consecutive applications—don't attempt it in one shot. Allow each application, and the lace, to dry. If the lace becomes saturated or wet, it will transfer blocked-up images, which will ruin the overall effect. An example of lace painting is shown on page 58.

Figures 11-18 through 11-23 show op art designs made with the aid of precut stencils.

Fig. 11-18. Cut op art stencil.

Fig. 11-19. Apply the stencil and airbrush. Items placed on the stencil hold it down flat.

Fig. 11-20. Rendered op art design. It may be used singly, in line, or in overlay patterns.

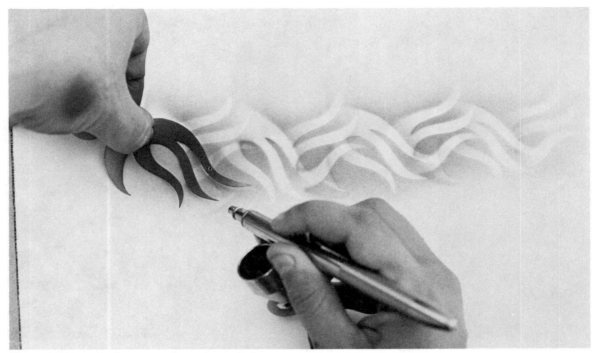

Fig. 11-21. Here, another pattern is used repeatedly.

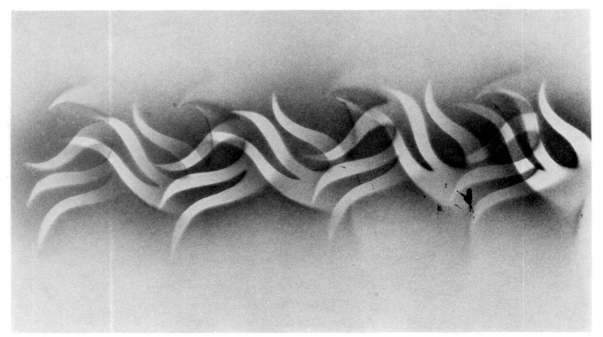

Fig. 11-22. The completed overlay pattern.

92

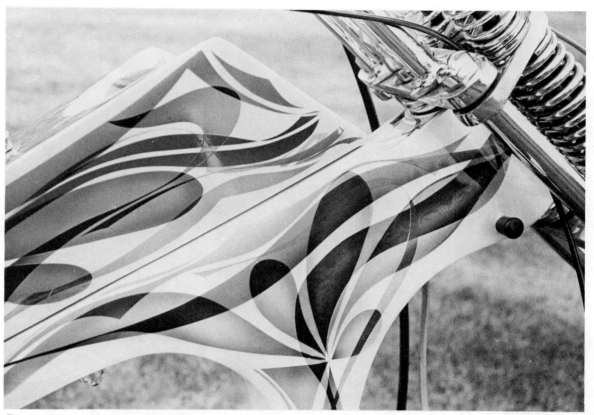

Fig. 11-23. Another completed example of an overlay pattern. This one, an op art candy overlay motif, is on a motorcycle neck and tank.

Geometric Forms

Practically all form is based on geometrics or a combination of geometrics. It is of the utmost importance that the serious airbrusher learn how to achieve and manipulate geometric forms because they are fundamental to technical as well as illustrative artwork.

The exercises and studies that follow are a considerable step up from the basic airbrush drills. You should master the geometric structural shading techniques exemplified by these common shapes before you proceed to more exacting airbrush techniques.

THE SPHERE

The most basic, and hence the easiest, geometric figure is the sphere. It is so simple to execute that even the novice can tackle it the first time out; in fact, some say that the hardest part of this exercise is cutting a perfectly circular stencil.

First draw a circle using a compass or a commercial draftsman's stencil. If these items are not available, the rim of a drinking glass will suffice; tracing around the rim will provide an excellent circle. Then cut out the stencil (use Bienfang waxed paper stock for all the shapes described in this chapter). Discard the central portion (Fig. 12-1).

Lay the circle stencil over the piece of paper to be airbrushed and you are ready to begin. If the stencil is large (6 inches or more) it may be wise to lay a few pennies or coins around the stencil's circumference to keep the stencil flat in order to minimize underspray seepage.

Now, begin a circular motion on the outside perimeter of the circle stencil and lightly fog in the edge of the circle (Fig. 12-2), then spiral in slowly (keeping the airbrush on an equal spray setting throughout) toward the center of the sphere, allowing about one-third of the sphere to remain untoned. Next, spiral out again toward the edge of the sphere, applying more tone to the peripheral edge to give it more dimension. Figure 12-3 shows three variations on the sphere, all arrived at by using this method.

Fig. 12-1. Cut a circle stencil.

Fig. 12-2. Tone around the circle's circumference; build up tone toward a highlight as explained in text.

Fig. 12-3. Variations on the sphere.

THE SQUARE AND THE RECTANGLE

Two other distinctive geometric shapes are square and its relative, the rectangle. Whereas the square is equal on all sides, the rectangle has two short sides and two long sides. The three-dimensional box in the demonstration that follows (Figs. 12-4 to 12-8) is comprised of both shapes: the front is a square; the top and side are rectangular (note that the rectangles are presented in perspective).

Three sides are presented visually in this geometric rendering, so, consequently, a three-part stencil must be fabricated. Draw the shape shown in Fig. 12-5 and cut it into three segments; then tack them back together, with each piece in its respective position.

To render this shape, first remove one segment of the rectangle and tone the first section (Fig.

12-6). After toning, cover the first rendered section with its stencil, then tone the second portion after removing its protecting mask (Fig. 12-7). Finally, return the second mask to its proper place and bare and tone the remaining segment. If you follow all the steps with care, you should have a shape like the one in Fig. 12-8.

Remember: all sides should vary in tonality or you will end up with a silhouette. The side facing the light source or direction in a drawing or illustration should always be the lightest in tone. Build color or tone up slowly, keeping the light values of all the sides in a proper ratio. If you intend to use frisket in place of stencil paper (you can get better-matching edges with stick-on frisket), keep in mind that tonal values appear lighter when covered with frisket.

The same procedure can be used to render a cube, which is equal on all sides.

Fig. 12-4. The cube is drawn out on stencil medium.

Fig. 12-5. A three-part stencil is cut.

Fig. 12-6. One section is removed and toned.

Fig. 12-7. The first rendered section is re-covered; the second section is uncovered and rendered.

Fig. 12-8. The remaining segment is uncovered, the previously rendered portions are recovered, and the last section is toned so that the rectangle is complete as above.

Fig. 12-9. Formulate the cone stencil.

THE CONE

The cone is the most unusual of the geometric shapes and has its own special identity. It is also the most difficult shape to render since it is comprised of tapered shading, which is more difficult to execute than simpler shaded forms (the sphere, cube, rectangle, and cylinder).

The cone comes to an equilateral point, while the base is elliptical. Figure 12-9 shows the formulation of the cone shape, using a commercial drafting stencil coordinated with a drawn triangle. The diameter line of the ellipse is placed on the base line of the triangle and traced. The triangle should be formulated so that the base line equals the ellipse diameter in order to form a proper cone.

Using the drawing as a guide, cut out a stencil (Fig. 12-10) and place it on the piece of drawing paper on which you will be rendering. Tone the two edges (Fig. 12-11); note that one side is toned darker. You should use the progressive expanding spray technique (described in Chapter 9) here since the cone tones emanate at the cone point but get progressively wider. Add more tone to intensify the dimensionality (Fig. 12-12). Figure 12-13 shows the finished piece.

99

Fig. 12-10. Cut out a cone-shape stencil.

Fig. 12-12. Add middle tones and highlights.

Fig. 12-11. Tone the edges.

Fig. 12-13. Finished cone.

Fig. 12-14. Another type of cone rendering.

Figure 12-14 shows a cone in a three-quarter study viewed from below. To achieve this conical rendition, first stencil and render the base ellipse, then the tapering side shadings. A two-part stencil (upper cone and lower ellipse) is necessary in order to execute this cone version.

THE CYLINDER

Another familiar basic geometric shape is the cylinder. The rendering approach is similar to the shading structure of the cone, with the exception that straight, gradated shading is used rather than the tapered shading typical of the cone.

Chapter 13

Airbrushing on Fabric

Airbrushing on fabric has become very popular in recent years. This is partly because T-shirts are a craze among children, teenagers, and adults.

Custom T-shirts are a personalized thing and you see more and more of them around. There are a number of astute airbrushers that have become active T-shirt artists; the field is both expansive and lucrative.

T-shirts as well as other fabric pieces may be rendered like all other airbrush art, but some minor factors must be considered. First, you don't just tear up a T-shirt or discard it to do another if you make a mistake in painting; it would be too costly. Second, it is difficult—nigh impossible—to erase or correct an error. Third, you must use specialized paints specifically formulated for fabric painting.

You should be proficient with the airbrush before you tackle airbrushing on fabric: it is a one-shot approach to air art rendering.

FABRICS

You will find cotton fabric the easiest to airbrush on but other fabrics can be used.

Cotton

Cotton seems the best airbrushing fabric surface medium. It accepts colors well (if they are compatible) and when properly treated the renderings become permanent. The most important factor to be considered with cotton is its highly absorbent quality. If the fabric is oversaturated with color, the color or rendering will spread like ink on a blotter.

Cotton takes a number of color mediums very well, making it the most desirable fabric to work on for the airbrush artist; hence the popularity of T-shirts, which are predominately all cotton or blends with high cotton content.

Versatex is a very popular airbrush dye specifically formulated for fabrics. It is water soluble and easy to use. Recommended thinning ratios are one part color to one part water. Variances on color-to-water ratios are actually up to the individual; every fabric artist seems to have his or her own formula dictated by style, color saturation desired, and airbrush being used.

Deka and Hot-Air colors, dyes similar to Versatex, are used in the same manner. Some fabric

color manufacturers offer additives that are said to improve the permanence of the dye itself. The additives should be used if available for the dye product chosen.

Tubed acrylics work well on cotton, as do Air Opaques, a new airbrush medium marketed by Badger Airbrush Company. The Air Opaques are ready-thinned. With cotton they should be further thinned about 25 percent; with polyesters, cellulose, or acetate fabrics, they should be used as is.

Velvet and Velveteen

Velvets and velveteens are a bit harder to airbrush since they contain a nap (or fuzzy) surface, but once you become accustomed to working against this characteristic, you should have no difficulty.

The best paint mediums to use on velvet fabrics are Badger Air Opaques or tubed acrylics diluted one part color to four parts water.

Polyester, Acetates, and Cellulose Material

These do not retain major color mediums as effectively as cotton does, but may be well and permanently rendered if the right pigment types are used.

Tubed acrylics diluted in a one-to-four ratio tend to adhere most effectively on the new miracle man made fabrics. Likewise, Badger Air Opaques and similar acrylic-based liquids work well.

Another problem with man made fiber materials is their nonabsorbent quality. Instead of saturating into the fiber, the color will lay on the surface. If a nonplastic adhering pigment solution is used, it will tend to come off when the piece of rendered apparel is run through a washer and dryer.

Surprisingly, automotive acrylics (lacquer) fare very well on man made fiber fabrics. This is because the lacquer thinning medium used tends to soften and bite into the plastic fiber materials, offering a high degree of permanence. The only negative factor with auto lacquer is its prohibitive cost. It can be obtained only in pint sizes, which cost about $4.00 to $6.00 a can.

Felt and Denim

Natural felts and denims are handled like cottons. They will also take the same mediums used in man made fiber rendering.

PAINTING T-SHIRTS

Little preparation is necessary for T-shirt painting, but certain basics should be followed. Whenever possible use a new shirt. T-shirts that have been washed tend to build up a cotton nap on the surface, and this will affect the surface, which will affect fine line detail rendering to a degree. On a brand new T-shirt, this nap is held down by the sizing in the shirt and this provides a smoother surface texture better suited to airbrushing.

If you must use a well-washed T-shirt, iron it first with moderate heat, placing a piece of kitchen wax paper between the iron and the shirt. Some of the wax in the paper will transfer to the cotton surface and will keep the nap down.

Two brands of fabric dyes or paints are particularly effective for T-shirt art rendering: Ver-

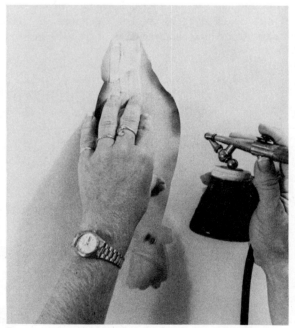

Fig. 13-1. First a cut out shape of a parrot is laid against the surface of the material and outlined by fogging around the edges.

Fig. 13-2. A limb for the bird to perch on and flowers are airbrushed freehand.

Fig. 13-4. Eye and detail cutouts placed in the bird outline stencil are then placed over the original bird outline. Black is airbrushed through these openings.

satex and Deka. Both are water soluble and, once dry, the fabric will remain colorfast for the life of the shirt. These dyes are thick in stock form and must be watered down somewhat in order to be airbrush compatible. One part dye to one part water is a good basic formula. For extra-fine rendering, you may have to add an additional part of water.

When airbrushing T-shirts you should make

Fig. 13-3. The pistils are put on the flower. During this step dimensional shading is also added.

Fig. 13-5. Contrasting detail coloring is now added. Note the eyes, beak, and feet added in the previous step and the flat look of the undetailed bird compared to the flowers and limb.

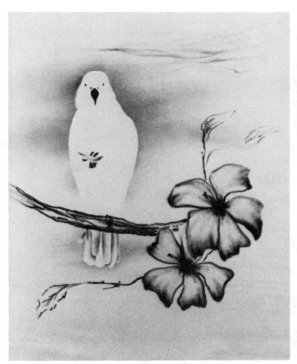

Fig. 13-6. Closeup view of the rendering. The cloud detailing in the sky is done freehand.

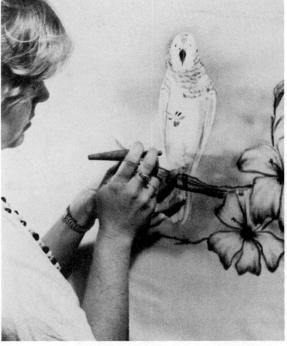

Fig. 13-7. The bird is toned and shaded, and further detail is added.

sure that the fabric is not allowed to be oversaturated with paint in order to minimize possible blotching and running. Color should be built up slowly and gradually, rather than thrown on in one shot: The paint will apply more evenly and you will have more control. After painting is completed, iron the T-shirt in order to make the artwork colorfast and permanent.

Many T-shirts are hand rendered, but a combined hand and stencil approach is also widely used. Figures 13-1 through 13-8 show a typical approach to T-shirt or fabric art. It is a refined study in fabric art by Nancy Scoble, a prominent airbrush artist from Ft. Lauderdale, Florida. For this step-by-step demonstration, Versatex dyes were administered with a Paasche Model H airbrush with a #3 head. (Other examples of Miss Scoble's work may be studied on pages 64 and 65.)

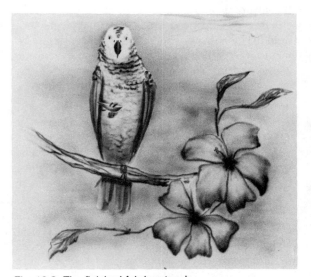

Fig. 13-8. The finished fabric artwork.

Chapter 14

Hobby and Craft Uses

Although primarily an artist's and retoucher's tool, the airbrush is gaining its greatest popularity—along with expanded sales—in hobby and craft fields. The airbrush can be used with or applied to virtually any hobby or craft involving coloring, staining, spray coating, or glazing.

CERAMICS

The airbrush is becoming as popular as the sable brush for decorating ceramic vases and objects d'art. Stencil design motifs and freehand illustrative effects are seen more and more often as ceramic hobbyists and craftsmen opt for the increased versatility of the airbrush.

Conventional airbrushes are ideal for overall glazing of small pieces. The more efficient, larger airbrushes will tackle larger pottery pieces. Ceramic glaze can be applied more evenly, with no streaking, when shot through an airbrush or small spray gun. For artwork, tonal shading and gradation are easier to achieve with the airbrush, particularly if the piece to be rendered is very porous.

FISH TAXIDERMY

The airbrush is the rendering mainstay in fish taxidermy, since the shadings and blends that fish coloring is comprised of can only be achieved by fine spray rendering.

Automotive lacquers are used by professional and amateur taxidermists alike because these have the qualities needed to emulate the realism of nature's colorings. Transparent tones and lacquers most applicable to taxidermy color facsimile can be obtained at auto paint supply houses. The better brand of lacquer for this purpose is the type manufactured by Ditzler. These lacquers must be thinned out considerably for use in the airbrush and the airbrush must be constantly cleaned and flushed throughout use to combat paint buildup around the small, delicate paint orifices.

Pearl pigments, necessary in order to emulate specific fish colorings, are also made by Ditzler. They come in standard pearlescent colors covering all the hues that can possibly by found on fish skin. The standard Ditzler concentrates for pearl toning

Fig. 14-1. The fish eye is masked out and shading is applied around the eye.

Fig. 14-2. Black is shaded into recessed areas around the mouth.

Fig. 14-3. Highlights (silver) are added.

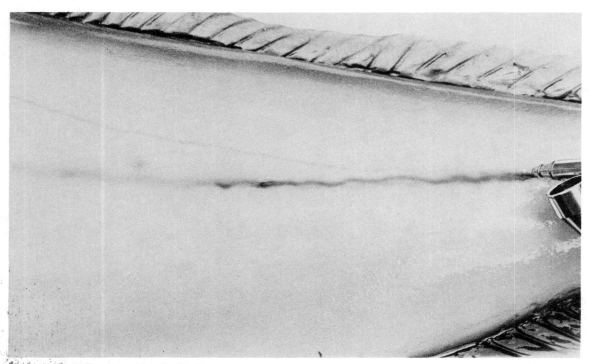

Fig. 14-4. Body lines are airbrushed in finely.

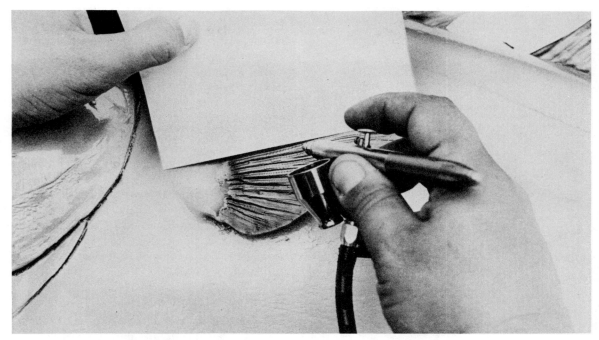

Fig. 14-5. Fins are toned and shaded.

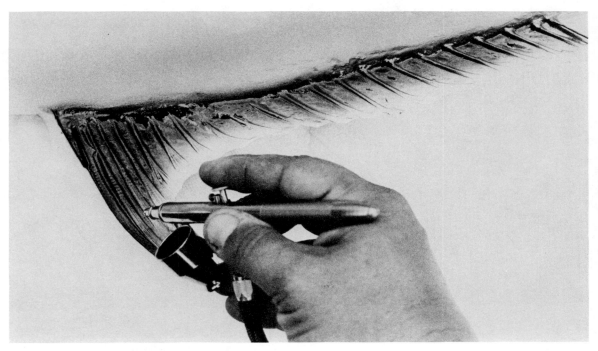

Fig. 14-6. The bottom belly fin is toned and shaded.

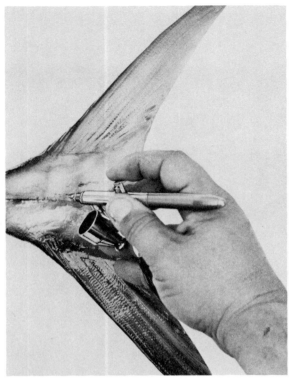

Fig. 14-7. Detail is added to the tail.

are: DX-90 Sunset Red; DX-91 Phosphor Green; DX-92 Frost Blue; DX-13 Tincture Gold; and DX-94 Platinum Star. These pearl concentrates come in a paste form and must be added to clear acrylic lacquer and then diluted considerably. The proper mixing ratios and application of automotive pearls and color tones through the airbrush are explained in detail in Chapter 15.

After the fish is completely colored and shaded, a spray coating of acrylic urethane (Ditzler DAU-75) should be administered with a production spray gun or a heavy-duty mini gun, such as the Badger 400. This will give the finished piece its authentic shine or "wet" look as well as a desired protective coating. Figures 14-1 to 14-8 show the typical fish-coloring procedure common in fish taxidermy. For a color picture of airbrushed fish taxidermy see page 64.

FLYING MODELS AND BOATS

These gas-driven crafts are painted with special paint called dope, the most popular being the Aero Gloss brand. Lately, however, urethanes have been gaining popularity as color-coating mediums. Dope may be administered by airbrush but acrylic

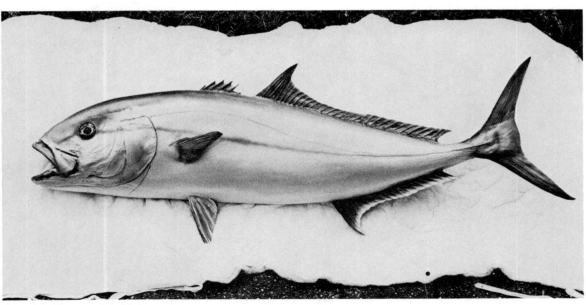

Fig. 14-8. The completed fish.

Fig. 14-9. Akane 2-8-0 painted with Flo-Quil Engine Black.

urethanes cannot, since permanent damage may occur if these catalyzed mediums dry in the airbrush channels. For gas engine models of all types that require painting with dope or urethanes, only airbrushes or tools like the Badger 400 or Iwata HP-E should be considered.

MODEL RAILROADING

No model railroader should be without an airbrush. It is almost mandatory for refined scenic work, model weathering, painting metal locomotives and rolling stock, and even for painting scenic backdrops.

Metal and brass locomotives (or rolling stock) must be spray painted since the proper lacquer (Flo-Quil) requires spray application for a natural, realistic appearance. Before painting the cars, etch the metal in a mild acetic acid bath. Then wash and dry it. A couple of coats of Flo-Quil primer should then be administered, after which the model may be color coated. Model Railroad lacquers should be thinned somewhat, using the recommended thinning given in Chapter 8. Engines should be disassembled before painting so that important adjoining parts will not be oversprayed. Figure 14-9 shows a painted Akane brass 2-8-0 as it would look in new condition.

Fig. 14-10. A weathered look being created with the airbrush.

Fig. 14-11. "Dusting" an old box car.

Fig. 14-12. Fine camouflage airbrush rendering on jet aircraft (courtesy Universal Hobbies, Ft. Lauderdale, Florida).

Fig. 14-13. P-40 Warhawk replica painted and detailed by Ed Witlin. Paint: Testor's flats and Poly-S.

Fig. 14-14. M-32 Armored Recovery Vehicle painted and weathered in Pactra Military Flats. Model and airbrushing paint work by Ed Witlin.

Fig. 14-15. Side view of the M-32 in Figure 14-14.

Fig. 14-16. Airbrush detailing on a superb World War II diorama. Modeling and paintwork by Ralph Gimenez, Tamarac, Florida.

Weathering is another detailing process well handled by the airbrush. Dust and rust coloring can be hazed on, giving a natural faded look or one of progressive deterioration. In Fig. 14-10, a building is aged using umber stain to simulate dirt and discoloration (see also page 70). In Fig. 14-11, a box car is aged using Flo-Quil Dust stain hazed on heavy in some areas, light in others.

MODELMAKING

Models (planes, armor, dioramas) should be airbrushed for optimum appearance. Many airplanes wore camouflage markings, which are more realistically duplicated with the airbrush than with any other medium since the prototype marking were themselves applied with spray guns creating soft edges on varicolored splotches. This effect is best simulated with airbrush spray rendering.

Figures 14-12 through 14-16 are outstanding examples of the proper application of airbrushing in scale modeling. The airbrush and construction work was undertaken by two fine model craftsmen and detailing experts. You can see for yourself the quality and realistic effects achieved with airbrush painting and detailing. For color pictures of these models see pages 68 and 69.

Chapter 15

Automotive Customizing

Automotive, and motorcycle, customizing covers a wide range of techniques—from body sculpturing to painting. Our basic concern in this book is with murals and graphics, which in most cases are rendered with airbrushes and related techniques.

It is in this type of airbrushing that the choice of airbrushes is most critical. This is because "customs" must be airbrushed with acrylic lacquers, the only compatible paint medium that can be properly used over automotive paint. Lacquers are also the only pigments that will adhere to automotive paint surfaces.

Numerous examples of airbrushed murals and graphics on motorcycles, cars, and vans are given in the color section (see pages 58, 59, 61, 63, and 67).

SELECTING THE AIRBRUSH

Since lacquers dry so rapidly (almost instantaneously), they are naturally highly coagulable. Because their main property is their positive adhesion to metal surfaces, they will tend to leave pigment deposits on the inner mechanisms or channels of the airbrush. For this reason you must choose an airbrush that is adaptable for trouble-free lacquer painting.

One of the most applicable of the spray tools is the Badger 400 touch-up gun. This gun contains a wide nozzle orifice and wide paint channels within since it is primarily designed to handle acrylic lacquers and other automotive paints. The 400 is ideal for general custom enhancement and muralization of large area; it is, however, not fine enough for super-detailed work. For finer, more exacting and critical rendering, you must use the basic airbrush: one that is able to handle lacquers yet is refined enough to render critical detailing.

The airbrushes I recommend for customizing work with lacquers are the Iwata HP-E2, the Paasche VL-5, the Badger 150, and the Badger 200.

The Iwata HP-E2 is primarily designed for lacquer use; the paint passages are ample enough and do not clog easily. The nozzle and needle arrangement is such that fine rendering can also be achieved, though not as fine as with other more

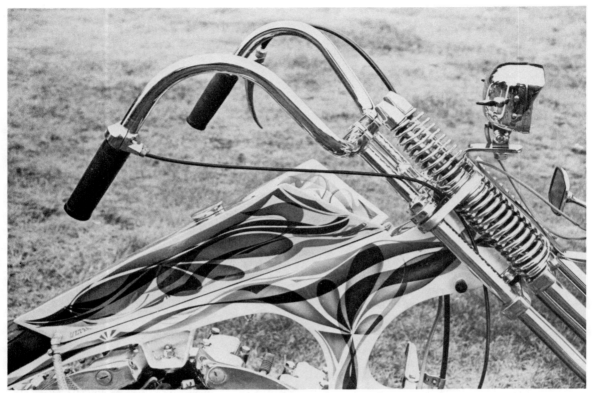

Fig. 15-1. Bob Izzo's *Right On* is "right on" with candy overlay artwork.

common airbrushes. A large color feed cup is also provided with this model, which is handy.

The Paasche VL-5 is an instrument capable of fine rendering while not too prone to clogging, provided that the airbrush is cleaned and flushed frequently throughout use. This unit's versatility is expanded with the option of fine or wide tips and needles, and large paint jars.

The Badger 150 is capable of doing very fine work and holds up well with lacquer in spite of its fine tip and passages. Paint cup options (up to 2 ounces) are also available with the 200, as are fine and heavy-duty tips and needles. The Badger 200 will execute the same fine work as the 150. It is a single-action airbrush, yet it is popular because it is inexpensive as well as effective for detailing.

SELECTING PAINTS

Although you are restricted in automotive and motorcycle customizing to colors that will adhere to metal, there is a variety of suitable colors to choose from.

Customizing Lacquers

There are a myriad of automotive acrylic lacquers on the market, all shades, hues, and densities, in both opaque or transparent version. The opaque colors are usually standard auto colors, the transparent hues or toners, mainly used for tinting but applicable for trick transparent effects and color overlays.

A word about lacquer thinners. Three grades of lacquer thinner are marketed for acrylic lacquer painting: slow dry; medium dry; fast dry. Quick-dry thinners are of a cheap grade and are not recommended for airbrushing since their quick-dry characteristics make them overly coagulable. Medium-dry thinners are good for overall air-

brushing and fare well in airbrushes. Slow-dry thinners are most desirable when doing fine and line rendering and tend to stay in a "wet" state longer. Adapt the proper thinner to the work you are doing for foolproof, trouble-free results.

A word of *caution:* lacquers and their thinners are highly toxic. Avoid breathing them in at all costs. Always use a protective lacquer-proof mask when airbrushing with these dangerous paints since their strong fumes can cause lung, brain, and bone damage.

SPECIALIZED "TRICK" PAINTS

There are a variety of specially formulated lacquers known in custom circles as "trick" paints because of the unusual effects they exhibit when used singly or in conjunction with standard lacquers. These "trick" mediums can be airbrushed successfully provided they are properly prepared and diluted for airbrush use. Following are some of the "trick" paint mediums available and their characteristics.

Candies

Candy paints are in reality automotive toners; when used by themselves they are transparent, hence the term candy paint. A full line of Candy Apple paints are marketed by Metalflake Inc., a company specializing in custom "trick" effect paints. Ditzler also produces a line of candy paints under the Star Apple label. Since candies are transparent, you must keep in mind that any color applied underneath the candy coat will show through the candy overcoat (Fig. 15-1). Candies should be applied in thin, hazed coats; tonality should be built up progressively. Sometimes groundcoats (white, silver, gold) must be used under the candies to enhance or heighten the color effect. For airbrushing, candies should be mixed one part pigment to three parts thinner.

Pearls

Pearls are in a class by themselves and are easily distinguishable by their pearly appearance and eye-catching iridescence (Fig. 15-2). There are two varying types of pearls marketed for custom

application: Star Pearl and Murano Pearl. The Star Pearl, though somewhat transparent, have a denser buildup when applied over a complimentary base and radiate an even pearl tonality and hue, depending on underbase color applied. Murano Pearls are almost completely transparent. Their function is to allow a pearlish cast to predominate when the surface is viewed from an acute angle. Viewing Murano directly allows the undercoat color to predominate. Since the iridescent intensity of Murano varies as it is viewed from different angles, it has been nicknamed "flip-flop" pearl.

Star Pearl is available ready to spray in airbrush-ready consistency from Metalflake Inc.

Fig. 15-2. A Pearl flame and shaded line motif; The Knucklehead Harley is the property of Roger Sposa.

Fig. 15-3. Tasteful graphics by Garrett Miller using Vreeble (crackly band) and candy toners.

These Pearls are contained in small 4-ounce cans.

Murano Pearls are also marketed by the same company, airbrush ready. The Ditzler Corporation offers bulk Murano Pearls in a paste form, which must be added to clear acrylic to form a working solution. For airbrushing, one-quarter teaspoon of Murano paste to 4 ounces of clear acrylic, diluted one part Pearl/clear to four parts thinner, is perfect. Pearl tones, like candy tones, should be hazed on and built up slowly.

Vreeble

This is another wild trick paint; it "cracks up" as it dries, creating some unusual design effects. A tasteful use of Vreeble is seen in Fig. 15-3. Vreeble is mixed and airbrushed in the same manner as standard automotive lacquers.

Metallics

Fine metallics, such as those formulated for standard automobile painting, can be airbrushed, provided a heavy-duty, large-orifice airbrush is used. After spraying metallics, and intermittently while painting, the airbrush should be thoroughly flushed out.

When airbrushing acrylic lacquer, keep a jar or color cup filled with thinner on hand and use it between color changes and between painting stints to minimize blockage and paint buildup on the needle and spray nozzle.

MURAL RENDERING

Murals requiring fine detail also require fine detailing airbrushes. In addition, the paint may have to be diluted more than four to one in order to spray

Fig. 15-4. This *Spacy Theme* graces a South Florida show van. (Painting by Shelby Goode of Naranja, Florida.)

the minute amount necessary for detailing. The fine-rendering airbrushes that hold up best seem to be the Badger 150 and Paasche VL-5. They can execute infinite detail and don't tend to clog up as easily as their contemporary counterparts. A one-to-five paint-to-thinner ratio is suggested for mural detailing.

Figures 15-4 and 15-5 show outstanding examples of airbrush mural work. Figure 15-6 shows mural work coordinated with line graphics.

Mural artwork is fairly simple to execute with an airbrush, as exhibited in Figs. 15-6 to 15-14. The rose was for the door of a custom car and was placed beneath the handle area to add a "touch of class." Here's how it is rendered.

First, a drawing of the rose is made to size (Fig. 15-6); this serves as the mechanical from which the airbrush stencils can be made. Next the primary stencil (the rose-rendering procedure consists of a three-stencil plus freehand compilation) is taped into place (Fig. 15-7) and the first color (red) is airbrushed in, using the red heavily in some areas and lightly in others in order to create a dimensional

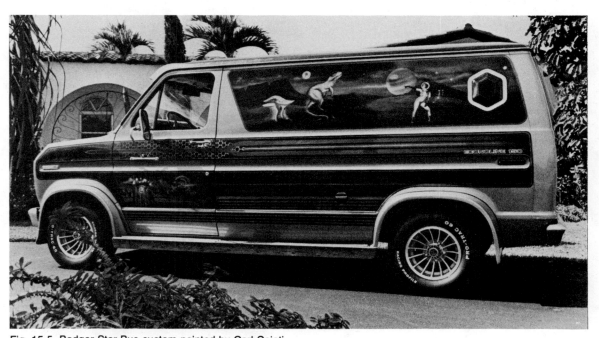

Fig. 15-5. Badger Star Bus custom painted by Carl Caiati.

Fig. 15-6. Drawing for rose stencil.

effect (Fig. 15-8). Figure 15-9 best illustrates the shading effect achieved. Next, a second stencil is secured in place and handled in the same manner as the previous one, allowing some petals to superimpose on the previously painted petals (Fig. 15-10). These are toned with a darker shade of red (Fig. 15-11). Freehand rendering is done next (Fig. 15-12) to blend and shade the in-between areas not stenciled. The leaves are then airbrushed in using a third stencil coupled with fine hand detailing (Fig. 15-13). Figure 15-14 shows the finished rose.

Other examples of automotive graphics are shown in Figs. 15-15 through 15-17.

If you are not interested in auto and bike enhancement, you can still use this approach for painting figures on other select surfaces: paper, wood, plastic, for example.

Fig. 15-7. The first stencil is taped into place.

Fig. 15-8. The first stencil is filled in and shaded.

120

Fig. 15-9. First step complete.

Fig. 15-10. The second stencil is applied.

Fig. 15-11. Second stencilwork is undertaken.

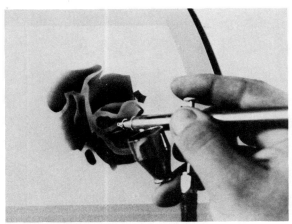

Fig. 15-12. Adjacent areas are filled in freehand.

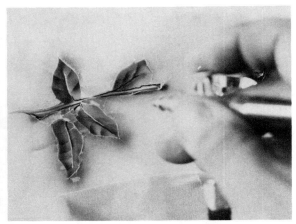

Fig. 15-13. Leaves and stencils are detailed.

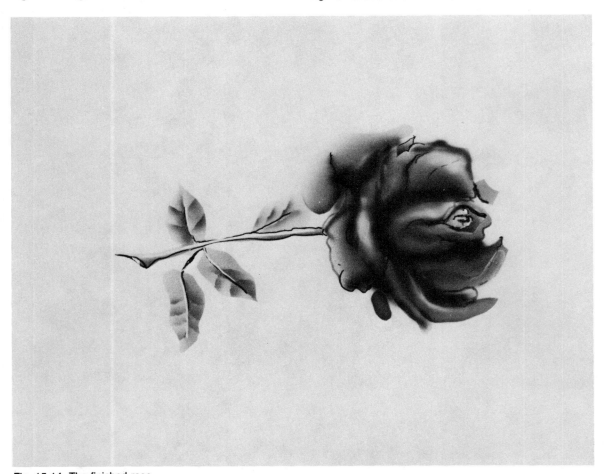

Fig. 15-14. The finished rose.

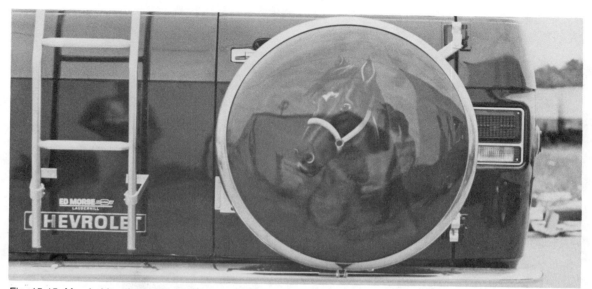

Fig. 15-15. Mural airbrushed on the wheel cover of a van (by Carl Caiati).

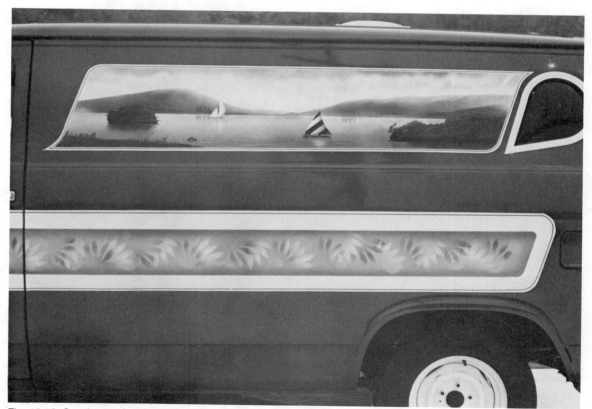

Fig. 15-16. Scenic mural and decorative detail added to a van (by Carl Caiati).

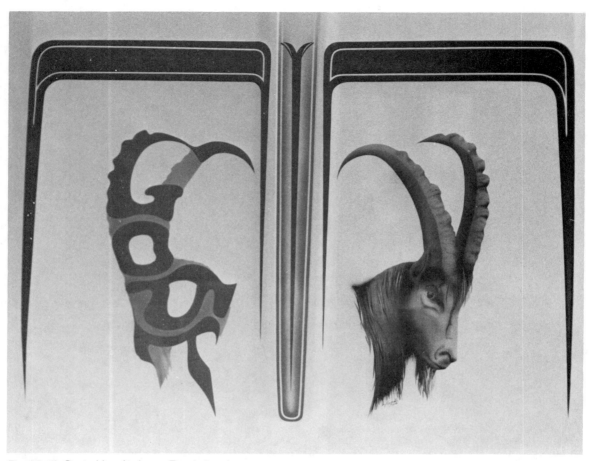

Fig. 15-17. Goat airbrushed on a Toyota hood.

Chapter 16

The Airbrushed Landscape

The airbrush is unique for landscape rendering since the artist can achieve both hard, sharp effects (with the added use of stencils) or soft effects using the airbrush alone.

Progressive tone blending, so necessary in sky effects, can be built up using the graduated tone procedure described in Chapter 9. Mist and fog effects are easy to execute and manipulate, as are soft, distant haze effects. Interblending, fading of colors, shading—all are specific procedures you can use when painting with this great tool.

The airbrush is tailor made for cloud rendering. A very simple but striking cloud effect can be achieved using the airbrush, with a torn piece of paper serving as a stencil. Place the torn edge against the paper and fog the edge with the airbrush. Then move the paper down and shift it around in progressive stages until the cloud effect illustrated in Fig. 16-1 is achieved.

The same torn paper approach can be used for getting effects of distant hills and mountains. Holding the torn edge firmly against the paper gives a sharp outline effect; holding it off the surface, so that the edge does not contact the paper allows soft edge effects.

You can achieve tree effects (Fig. 16-2) by airbrushing through a stencil, which, in fact, is the only way to get hard edges in airbrushing.

Freehand airbrushing is preferred by many for soft cloud effects, duplicated far better by airbrushing than by any other known rendering mediums.

The color pictures on pages 56 and 57 show a step-by-step airbrushing approach to landscape painting, using both stencil and freehand technique. Another example of an airbrushed landscape is given on page 62. Figure 16-3 illustrates an imaginative use of a landscape to decorate a closet door.

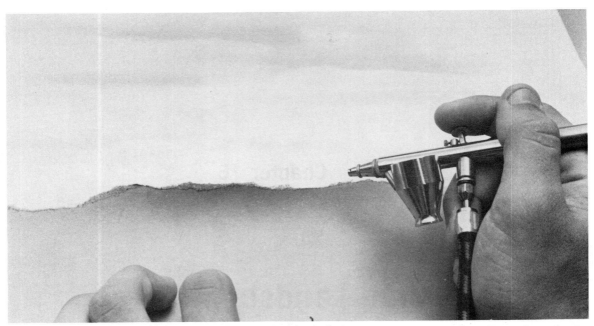

Fig. 16-1. Airbrush and torn paper technique for rendering cloud effects.

Fig. 16-2. Stencils should be cut for trees if they are to have hard-edge definition.

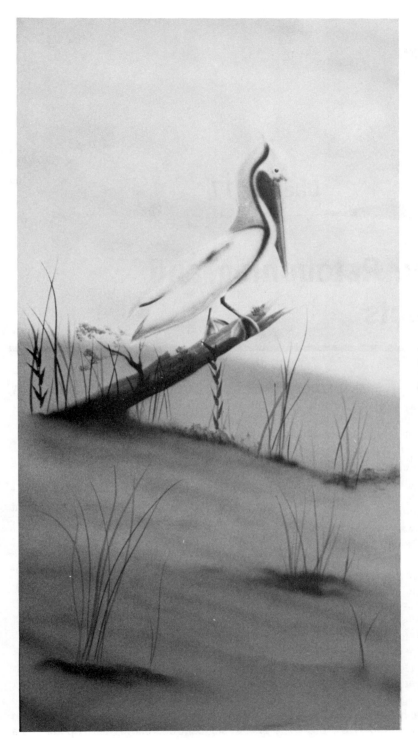

Fig. 16-3. Sand dune, driftwood, and pelican silhouetted against a morning sky. The scene is painted on a closet door (by Carl Caiati).

127

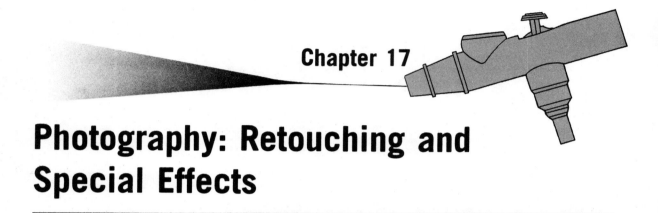

Chapter 17

Photography: Retouching and Special Effects

The airbrush is equally as popular in the field of photography as it is in illustration. It is the only instrument or system that can duplicate photographic tonal gradations as well as soft focus effects. This air tool is so exacting that it is impossible to discern if a photo has been manipulated or altered, providing the retoucher is an astute craftsman. Virtually thousands of the photo ads the public sees daily have been altered for aesthetic or color values or to eradicate flaws.

This chapter deals with some of the most common situations encountered by the average retoucher and discusses the corrective and enhancement procedures necessary to achieve an improved, finished rendering.

Although the airbrush, per se, is a fairly universal and versatile instrument, for photo retouching only the fine-rendering, more delicate ones are recommended. These are needed to execute the ultrafine linework, subtle gradations, and shaded nuances encountered in photographs. The airbrushes best suited for photographic retouching are the Badger 100 X-F, the Badger 100 GXF, the

Paasche AB (turbo), the Thayer and Chandler AA, and the Iwata HP-A and HP-B models.

RETOUCHING AND CORRECTIVE MEDIUMS

Paint mediums for photographic retouching are limited, but those available will handle all situations encountered. Retouching tints are either transparent or opaque; each type serves a different purpose. The transparent types (aniline dyes, for example) are primarily for tinting and minor corrective retouching. The opaque mediums are desirable for their "blocking" characteristics, crucial for radical corrective retouching. Let us examine the various types of media provided for the photo-retoucher.

Spotone

Spotone is a photographic dye used for black-and-white retouching. It comes in a three-bottle set containing black, blue, and sepia dyes; when used singly or combined, these dyes can match or tint to any graded segment of a photograph. Spotone is a

transparent dye that is absorbed by and becomes part of the film emulsion of the photograph when applied. It is not a heavy or "blocking" pigment and its tonality must be built up slowly, with consecutive light, even applications. It is ideal for toning down light areas and for shading. Spotone comes diluted and may be airbrushed straight from the bottle; for more subtle effects, it may be further diluted with water. Once applied, Spotone becomes permanent when it dries and cannot be washed off or removed, so be careful when using it and make sure that the tonal buildup is gradual. Since there is no heavy pigment buildup in the airbrush, it can be easily and effectively cleaned by flushing and spraying water through it when you are finished with the retouching. Spotone may be obtained through photographic outlets.

Color Print Retouching Colors

These retouching dyes are specifically de-

signed for color print airbrush and brush retouching and, like Spotone, are transparent pigments. Packaged in 14-color sets (Fig. 17-1), these tinting dyes spray magnificently through the airbrush and may be used straight from the bottle. Since they are water-compatible, they may be diluted with water if necessary.

Retouching Grays

Primarily gouache type pigments, retouching grays are manufactured singly or in sets by Winsor Newton and Grumbacher and may be obtained at better art supply and photographic outlets (Fig. 17-2). The pigments come in various shades of gray, black, and white and are specially formulated and color corrected to match all the possible tones that appear in a black-and-white photograph. These pigments are water soluble but are so viscous (Fig. 17-3) that they must be diluted at least one part pigment to five parts water.

Fig. 17-1. Colorprint Retouch Colors. These dilute dyes are especially designed for color print tinting and retouching.

Fig. 17-2. Grumbacher retouch grays.

The prime qualities of the Winsor Newton and Grumbacher grays are opaqueness and their close match to the gray tones found in photos. They can also be swabbed or washed off easily if errors occur. However, since these pigments do not become permanently waterproof when dry, care must be taken with photos retouched with the gouache grays because they will smudge.

Badger Air Opaque

Air Opaque colors were not primarily designed for photo retouching but may be used with excellent results for this purpose. Acrylic-based Air Opaque colors adhere well to the photograph's surface and when dry are permanently waterproof. Air Opaque will airbrush well right out of the bottle for most rendering; for retouching, however, diluting the paint one part color to one part water is advised. This will enable you to achieve finer detailing, and the thinned solution will minimize paint buildup and clogging of the airbrush. Tones should be built up slowly with light, consecutive, one-shot strokes.

Fig. 17-3. Retouch grays are thick and viscous. They must be thinned considerably for proper airbrush spraying.

ARCHITECTURAL PHOTOS

Figure 17-4 shows a building in one stage of construction. The problems here are a dull, drab, cloudless sky and visible power lines in the middle right portion of the photo. Since the wires are in the sky portion of the photo and have no pertinent details around them the sound solution is to cover the lines with cloud effects, which would also serve to enhance the bland sky. (The techniques for airbrush cloud rendering are covered in Chapter 16.) Figure 17-5 shows the retouched photograph. Note how the wires have been obliterated and the sky tones have been enhanced.

GLASS

Glass must be handled in its own way, and it almost always needs to be retouched because it cannot be properly lit photographically to bring up the glassy tone quality highlights and details all in one shot. This is due to the nature of glass and the fact that it can reflect false highlighting from studio and other light sources. The translucent tones of the glass usually must be airbrushed in, using airbrush washes of thin white coating. In Fig. 17-6 we see a figurine being toned. The figurine is masked off using photo maskoid applied with a round #2 red sable brush.

GHOSTING

Ghosting is another often-used effect in which areas surrounding the focal point of interest are faded out almost completely. In a majority of cases, masking of the main point of the photo is carried out using frisket film.

Figure 17-7 shows a stock photograph of a young woman on a rock. The model and the rock she

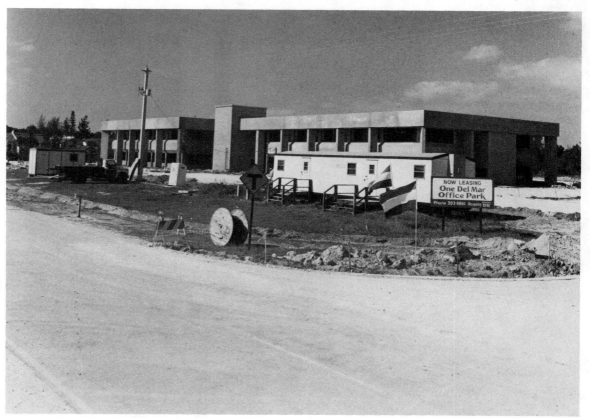

Fig. 17-4. Unretouched architectural photo.

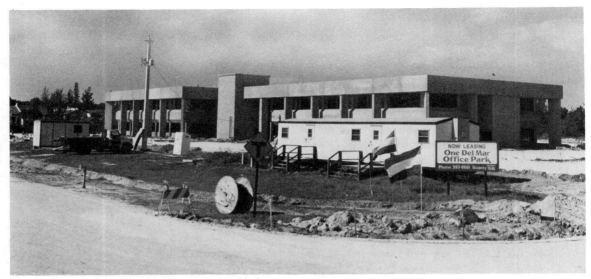

Fig. 17-5. The lines are removed and clouds added.

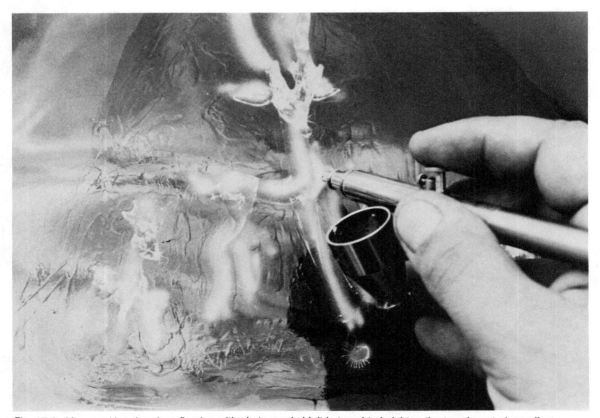

Fig. 17-6. After masking the glass figurine with photo maskoid, it is toned to heighten the translucent glass effect.

Fig. 17-7. Stock photo prior to airbrushing.

Fig. 17-8. Frisket film is applied, cut to mask the figure, and peeled off exposing areas to be ghosted.

Fig. 17-9. Ghosting is applied. When the hazed tone has dried, the masking film is removed.

Fig. 17-10. The finished "ghosted" print.

is perched on are to be the dominant images in the photo; the background and some of the foreground are to be ghosted out. First the photo is dry mounted onto a piece of illustration board for strong backing. Then a sheet of frisket film the same size as the photo is placed over the working surface. The masking film is cut following the outline of the girl. (A #11 X-Acto blade is the best tool for this type of cutting. Apply just enough pressure to cut through the frisket but not into the picture itself.) Next, the frisket film surrounding the girl is peeled off (Fig. 17-8) and a thin, even, overall wash is then built up around the girl (Fig. 17-9). The finished effect is shown in Fig. 17-10.

RETOUCHING OF PRODUCT SHOTS

Production and mechanical objects always need retouching, not because they cannot be photographed well but because they never appear flawless. The marketer, of course, wants the product being advertised to appear perfect, but this is almost impossible: inherent flaws, scratches, and imperfections are caught by the all-too-true eye of the camera. Retouching of the photograph is the solution.

Shiny objects, especially, must be retouched to minimize glare and to tone out unnecessary reflections that such surfaces pick up and, in some cases, distort. Chrome, stainless steel, silver, and other mirror-finish precious metals are notoriously hard to reproduce on film since they are so highly reflective. Glassware also falls into this category except that it is a more translucent medium with other varying properties (hence it was treated separately in the section on glass retouching).

Figures 17-11 through 17-16 show the retouching treatment of a chromed piece, a cutaway of a product shot of a spray gun. Note in Fig. 17-11 how reflections and distracting tones of the chrome appear dark in some areas while attaining a harsh whiteness in others. This is caused by mirror and studio light reflections. The light and dark radical tone must, therefore, be averaged out. In order to achieve a balanced overall effect, these reflections are usually phased out while washed-out areas are toned down. The darker areas are brought up to the

Fig. 17-11. Unretouched product shot.

Fig. 17-12. Frisket film is applied.

Fig. 17-13. The film is cut in the section to be altered.

proper tone of the object, usually by airbrushing with white. (Grumbacher retouching grays and white were used throughout this procedure.)

Study Fig. 17-11. Note how the trigger in the central top portion of the spray gun is glary and overly light in appearance. The internal workings of the piece, on the other hand, are dark—too dark to provide proper definition of the mechanisms and integrated parts. Likewise, the cap and tip (at the right end of the gun) are so dark that the grooves and channels are almost indistinguishable from the tone of the cap, which is actually about six values darker than the true color of the metal.

Figures 17-12 through 17-15 show work on the handle, which must have reflections removed and overall tone darkened to harmonize with the base tone of the product piece.

Retouching begins by covering the entire photo with a piece of frisket film (Fig. 17-12) and firmly pressing it down. Next the outline of the trigger is followed with an X-Acto knife (Fig. 17-13), cutting only through the frisket film. Then the masking film is removed (Fig. 17-14), baring the first area to be airbrushed. An overall even wash of pure white is applied over the unmasked section. Then a solution of dilute #4 Grumbacher retouching gray is mixed and the area toned, building up proper shadowing and dimensionality (Fig. 17-15). The other photo areas to be retouched are handled in the same manner.

Figure 17-16 shows the finished retouched piece. Note its more balanced tonality. The internal workings are more prominent and discernible. The trigger portion has been transformed into a finely sculptured entity. Study closely the nose piece (cap) at the extreme right of the piece. The channels now stand out, as does the inner nozzle, which has been lightened with overall highlighting (white) hazed on.

Product retouching is an important part of air-

Fig. 17-14. The film is peeled away exposing area.

Fig. 17-15. The section is toned and modified (corrected) with an airbrush.

brushing. It takes time to acquire expertise in product shot retouching, but it can easily be mastered with practice. Photo retouching can be a lucrative and fascinating venture for the serious airbrusher.

RESTORATION

Restoration usually involves the reconstruction of a torn, dismembered, folded, or damaged photo displaying devastation that must be radically airbrushed in order to bring it to an original or improved state.

Figure 17-17 is a typical example of an old, damaged photograph in need of radical restoration. Here the photo must be revitalized both in subject and surface damage. Spots and stains must be filled in; tear and fold marks must be airbrushed out.

Never, *never* work on the damaged original; you will accomplish little and possibly extend the damage. Make a copy print first, preferably larger than the original; it is always easier to make correc-

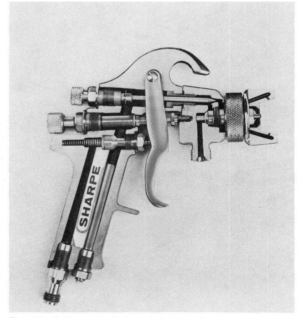

Fig. 17-16. Retouched photo (study text).

138

Fig. 17-17. *Left*: The damaged photo to be restored; *right*: the restored photo.

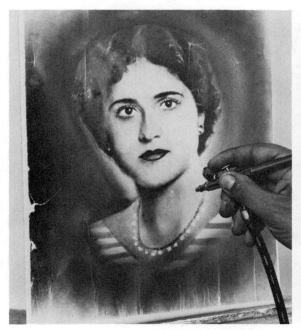

Fig. 17-18. Large masses are cleaned up and toned.

Fig. 17-19. Eyes are fixed, as are surrounding areas.

Fig. 17-20. Hair is put in order and fold marks airbrushed out.

Fig. 17-22. Lips are shadowed and their edges are softened.

Fig. 17-21. Chin and skin areas are toned and complexion cleaned up.

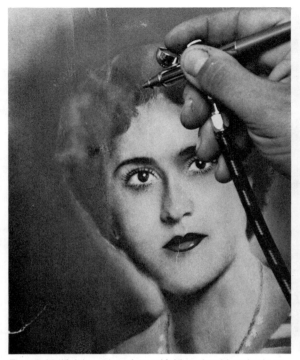

Fig. 17-23. Shoulders, chest, and neckline area are cleaned up and restored.

edges (Fig. 17-22). Next, the dress is reworked (Fig. 17-23), the crease marks filled in, and the foreground darkened evenly. Vignetting the figure into the background is next (Fig. 17-24). Highlighting the hair (Fig. 17-25) is the final procedure. Figure 17-26 shows the completed restoration print—a far cry from the original.

PORTRAIT RETOUCHING

Airbrush photo retouching can transform a mundane portrait into a work of art. So exacting is the airbrush for this type of work that when the expert retoucher has finished, the retouching is impossible to detect.

Figure 17-27 shows an unretouched portrait. Close scrutinization of the print enables you to see how unflattering this bad shot of a pretty woman is. First of all, the face is improperly lit, making for

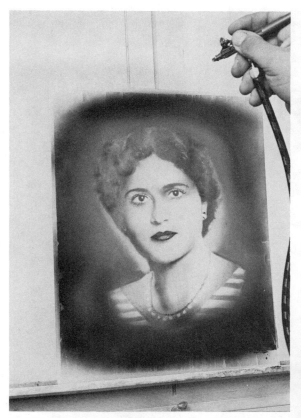

Fig. 17-24. The background is fogged and the head is vignetted into background.

tions on a larger format, consecutively reducing the corrected print down to the appropriate size by recopying.

Figures 17-18 through 17-26 illustrate the restoration process. In Fig. 17-17 the neck is erratically shadowed and damaged; it is muddy, too, so the clean-up restoration procedure begins here. The shadowy area around the eyes is also mottly, so I added a little shadowing and strengthened the eyebrows (Fig. 17-19). The hair looks artificial; it is livened up, with more body and detailing (Fig. 17-20). The chin is a bit hard and harsh, and a little too prominent, so shading and cleanup are necessary (Fig. 17-21). You will immediately notice on studying the unretouched print that the lips exhibit an artificial, stuck-on look. This shortcoming is easily remedied by softening and shadowing the

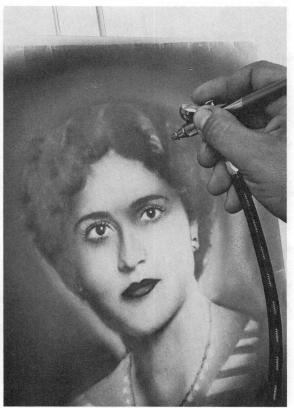

Fig. 17-25. Hair is highlighted.

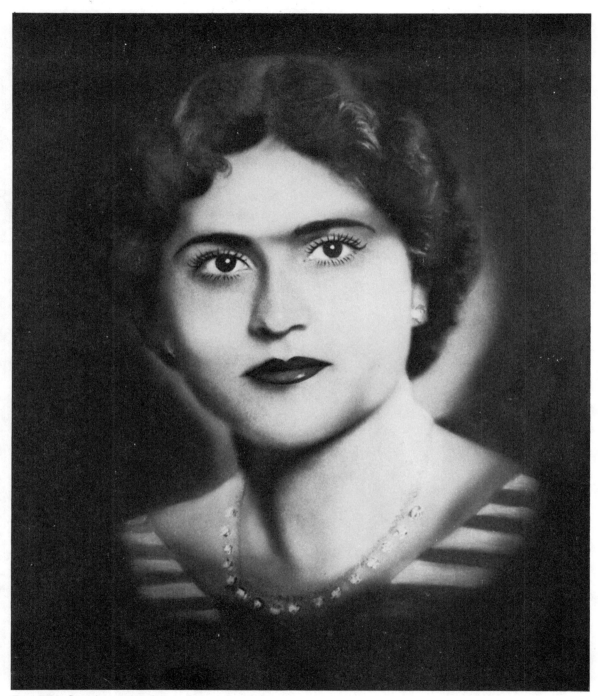

Fig. 17-26. Complete restoration.

Fig. 17-27. Portrait prior to overall retouching.

contrasting tones, harsh shadows, and hard feature lines overall. Wrinkles under the eyes are too prominent; the complexion is mottled; facial marks are prominent; and the eyes and jowls are too hard. Here's how you go about turning a harsh facsimile into a soft portrait.

First the hair is edge fogged (Fig. 17-28) to allow it to blend into the background color, softening the hair-to-background border. Then, work on the face itself begins. The shadowed area under the right cheek and jowl lines are softened with #1 Grumbacher retouch gray (Fig. 17-29). Next the eyes are worked on with the same color gray. Then the eyebrows are evened out with a very dilute solution #5 retouch gray (Fig. 17-30). The mouth is worked over next; lips, teeth, and corners are lightened with extremely thin applications of #1 gray (Fig. 17-31).

Fig. 17-28. Hair edging is toned lighter.

Fig. 17-30. Eyes are livened up.

Fig. 17-29. Jaw, jowls, and heavy shadowing is touched up.

Fig. 17-31. Lips and teeth are worked over.

Fig. 17-32. The chin is toned and highlighted.

Fig. 17-33. The portrait photo halfway done.

Fig. 17-34. Shoulders are ghosted and knees hazed out.

Highlighting to add some life to the face is next on the agenda. Cheeks, then the chin, are lightened with Grumbacher pure white retouch color. A special mark is cut (Fig. 17-32) to control overspray in the chin area. Now we see the face slowly shaping up (Fig. 17-33). The nose is next and gets the same lightening treatment as the cheeks and chin. The final steps include ghosting the shoulder and chest areas (Fig. 17-34) and completely ghosting out the knees (which are out of place and too prominent). The finished piece is a portrait worthy of praise (Fig. 17-35).

Fig. 17-35. The finished product: a great improvement over the original.

Chapter 18

The Airbrush in Illustration

The airbrush is the standby tool for the professional illustrator. It cannot be surpassed for emulating photographic realism and achieving special effects. The soft effects obtained with this tool cannot be duplicated by any medium but photography, and even at best, photographs cannot compete with or realize the exacting manipulative control of the effects possible with an airbrush.

In advertising, airbrush rendering is a mainstay, and airbrush paintings are preferred in many instances.

One interesting aspect of illustration is the cartoon rendering and a prime example is presented here. This how-to sequence was reproduced with the permission of the Badger Airbrush Company and is featured in their book, *Air-Brushing Techniques for Custom Painting* (see Bibliography). The cartoon rendering is of a badger, a comic creature from which the Badger Airbrush Company has derived its name.

The steps taken for the illustration are shown in Figs. 18-1 through 18-7.

First a drawing from which the working stencil will evolve is made (Fig. 18-1) on a piece of heavy paper or stencil stock. Stencilling is necessary in some aspects of the painting since hard- as well as soft-edge rendering is desired in some areas. The figure is then cut out; the background silhouette section will serve as the first stencil for laying out the figure. With the stencil tacked in place (Fig. 18-2) freehand airbrushing is administered to add shading and dimension to the figure. The inner cutout is then coordinated with the silhouette mask to formulate the second masking (Fig. 18-3).

The second hand of the figure is added after cutting out a second piece of the stencil as shown. Detail is added to the second hand with the airbrush, followed by a third area cutting, which exposes the sections to be consecutively sprayed another color (in this case, brown) (Fig. 18-4). The brown is then applied (Fig. 18-5). A piece of cut frisket serves to mask out the eye within the brown area. Freehand detailing and black shadowing is then administered as shown in Fig. 18-6. Figure

Fig. 18-1. Drawing out the stencil.

Fig. 18-2. The general areas are freehand airbrushed.

Fig. 18-3. A second segment is cut out for consecutive rendering.

Fig. 18-4. Area three is exposed.

149

Fig. 18-5. A second color is added with manipulative masking protecting areas previously toned.

Fig. 18-6. Freehand detailing is added (eyes, nose, shadowing).

18-7 shows a detail of the completed illustration with a little brushwork detail being added.

Two types of illustration practices prevail today in books, magazines, and general advertising photography and artwork; the airbrush is equally applicable to each for basic rendering or alteration and enhancement.

An excellent example of refined commercial advertising art is the book cover artwork shown in the color section on page 55. Paniagua is a well-known, highly competent Milwaukee airbrush artist, as the artwork that was used to grace Walthers' Catalog 1982 HO Railroad attests. His brochures and logo designs have won him high acclaim in the airbrush art field and gave garnished him a number of local and regional awards. The illustration exhibits good, flawless airbrush technique coupled with a strong sense of visual aesthetics.

Other examples of airbrush excellence are presented in this chapter. West Coast artist Jacqueline Metz is an astute and prolific airbrusher and a technician of the highest calibre. She has an affinity for always combining good artistic sense and values with impeccable taste. Her ideas are fresh and stimulating, and her technique approaching perfection. Metz is not only a fine artist and illustrator but an excellent photo retoucher as well and her mixed media (photo-art) concepts are exhibited here as well.

Although her primary love is illustration, Metz

Fig. 18-7. Finished illustration. Hairline detailing is added with a hairline brush (00 sable).

Fig. 18-8. *Gypsy and Airbrush*, a self-promotion illustration by Jacqueline Metz.

Fig. 18-9. Photo paste-up with airbrush retouching. This is a magazine ad photographed, composed, and airbrushed by Carl Caiati.

Fig. 18-10. *Felicia in Flowers*, by Jacqueline Metz.

has also gained reknown as a graphic designer, teacher, and demonstrator and has many trade shows to her credit. In 1978 she founded Metz Air Art, a formidable establishment that serves as a studio, store, an school for would-be airbrush technicians.

Figure 18-8 is the Metz logo, which shows her expertise as an illustrator. Figure 18-10 shows an innovative approach in a more modern artistic vein. Other examples of airbrushed illustrations are shown in Figs. 18-9, 18-11, and 18-12.

Fig. 18-11. Graphic art logo, by Jacqueline Metz.

Fig. 18-12. Magazine illustration by Jacqueline Metz.

Glossary

acrylic—Acrylic resin paint (usually tubed). It is water soluble.
acrylic lacquer—Automotive paint with toluene-based thinning agents.
air eraser—Small eradicating gun that sprays abrasive powder.
air valve—Unit controlling the flow of air to the airbrush. It is located at the air hose and airbrush junction.

Bernoulli principle—Law stating that fluid pressure decreases as velocity increases.
Blocking Out—Opaquing or covering over unwanted sections of a photo in retouching.
blowup—Circle of paint blown by airbrush on a surface by holding the airbrush in close proximity to the surface.

casein—Milk-based colors.
candy—Transparent acrylic lacquer tone.
cel—Transparent acetate used for overlays.
cobwebbing—Effect obtained when unthinned acrylic lacquer is forced through an air spray tool.

double action—Control that couples fluid and air output in an airbrush operating on this principle.

enamel—Oil pigment. It can be thinned by mineral spirits or turpentine.

fixed double action—Airbrush control system governing amount of paint and air released in a set ratio.
frisket—Masking sheet.

gouache—Water-soluble color with tempera or albumin base.

independent double action—Control that governs the amount of air paint released by independent actions of a common lever.

mask—Cut out or blocking medium controlling or confining the area to be sprayed.
medium—Type of paint used.
mural—Large painting executed on a wall or a dimensionalized scene or study.

needle—Internal airbrush metering component contrlling paint flow the nozzle.
nozzle—Orifice through which paint is released. It also contains the needle tip.

overlay—Transparent overtoning or overcoloring for added effect.
overspray—Excess overblow of airbrush spray.

pigment—Color particles that, when coupled with a base and thinning medium, produce paint.
print—Photograph; printed reproduction; mechanical artwork.
psi—Abbreviation for pounds per square inch, a unit of atmospheric pressure measurement.

rendering—Executing artwork or retouching.
reservoir—Compressor air storage tank.
retouching—Modifying or changing artwork or photo print.

single action—Control that releases air by trigger action. Paint is usually set at another location.
spider (or centipede)—Tendril or tentacle of paint created when the airbrush is too close to surface or paint is overly thinned.

turbo—Paasche AB airbrush containing miniature air turbine.

water-color—Water-soluble paint with gum arabic base.

Bibliography

Air Brush Digest.

This is an excellent, refreshing, authoritative, informative, classic magazine of interest to all airbrushers. Well illustrated and crammed with color, this bi-monthly publication features detailed how-to's plus a wealth of airbrush material necessary to the serious airbrusher. Subscriptions may be obtained from Air Brush Digest, 521 S.W. Eleventh Avenue, Portland, OR 97205.

Caiati, Carl. *Air-Brushing Techniques for Custom Painting, Vol. II*. Franklin Park, IL: Badger Airbrush Co., 1979.

This manual covers only the use and application of the airbrush in custom painting autos and motorcycles. The author, a specialist in auto aesthetics, covers all aspects of custom painting and its airbrush rendering approaches from op art design to muralizing. Examples of the leading automotive custom painters are included.

Caiati, Carl. *The Art of Custom Painting*. Havenhill, MA: Metalflake Corp. 1976.

Strictly dealing with automotive aesthetics, design, and muralization, this full-color manual also delineates the proper and accepted procedures for painting vehicles for "show" and "go." Some excellent airbrush tips for auto muralization and "trick" paint effects are also presented.

Caiati, Carl. *Hobby and Craft Guide to Air-Brushing*. Franklin Park, IL: Badger Airbrush Co., 1979.

This concise but informative, profusely illustrated how-to book details airbrush approaches to different hobbies and crafts. It shows how to airbrush comouflage on planes and tanks; fish (taxidermy); metal and plastic ships and trains; batik; fishing lures; and a host of other craft projects. It is a must for the hobbyist.

Curtis, Seng-gye Tombs and Hunt, Christopher. *The Airbrush Book*. New York: Van Nostrahd Reinhold, Co., 1980.

The material and techniques presented are fresh as well as informative. A strong point in this book is the lavish representation of contemporary works of airbrush art. A section featuring technical drawings of airbrushes and their operation is both enlightening and informative. Hunt and Curtis have done a good job of collaboration here.

Pascal, Robert. *Airbrushing for Fine and Commercial Artists*. New York: Van Nostrand Reinhold, Co., 1983.

This is an excellent how-to manual. Full-color illustrations cover the mechanics of fabric styling, printmaking, and taxidermy among other topics. The worksheet methods at the back of the book simplify reader experimentation with the airbrush. A bonus feature is a gallery of airbrush renderings of leading artists.

Custom Finishing Systems. Troy, MI: Ditzler Automotive Finishes, 1982.

This well-illustrated auto art handbook shows the everyday airbrusher how to achieve startling effects using specialized automotive lacquers. Ditzler markets candies, pearls, and other trick lacquer additives, and this book shows how to handle and apply these "trick" mediums. It has an extensive section on airbrush rendering on both cars and motorcycles.

Dember, Sol. *Complete Airbrush Techniques.* Indianapolis, IN: Howard W. Sams and Co., 1974.

Almost ten years old, this book is still a welcome addition to the roster of available airbrush books. Dember goes into infinite detail in all the phases of airbrushing he covers. The subject matter is almost all-encompassing. Very little concerning commercial, technical, and industrial airbrush application is left out. It is a very thorough book.

King, Walter S. and Slade, Alfred, L. *Airbrush Technique of Photographic Retouching.* Paasche Airbrush Co., 1965.

This book has been around for quite a while and for good reason. It is one of the most comprehensive treatises on photo retouching procedures and techniques. Illustrated instruction is given for all distinctive phases such as portrait retouching, glass retouching, ghosting, vignetting, photo montage, restoration, and much more.

Index

Photographs, paint for, 53
Photo restoration, 138
Photo retouching dyes, 50, 128
Photo retouching dyes, color, 129
Photo retouching masks, 83
Piston-action compressors, 23
Plaka caseins, 51
Plastic, paint for, 53
Polyester fabric, 103
Poly-S lacquer, 51, 112
Portrait retouching, photo, 141
Poster paints, 51
Printing inks, 51
Product shots, retouching, 135
Professional airbrushes, 12, 18

R

Railroad flats, 51
Railroading, model, 111
Rectangle, shading a, 96
Retouching grays, 129
Rockford Airbrush Company, 1

S

Safety precautions, 54
Sanhein, John, 55
Schlotfeldt, Walter A., 3
Scoble, Nancy, 64, 65, 105
Seckler, Chris, 66
Sharpe air regulator, 29
Shellacs, 50
Shiva, 54

Shivair Colors, 54
Shivairosol additive medium, 54
Single-action, external-mix airbrushes, 4
Single-action, internal-mix airbrushes, 5
Single-action airbrushes, 17, 18, 38
Sky effects, 125
Sliique, 62, 63
Spattering spray, 47
Sphere, shading a, 94
Spidering, 59
Spitting of spray, 47
Spotlighting, 75
Spotone dye, 128
Spray, pulsing, 49
Spray emission problems, 47
Spray ends, flaring, 49
Spray gun, 4, 12
Spray pattern, restricted, 49
Spray problem, grainy, 48
Spray regulator cleaning, 42
Square, shading a, 96
Star Apple paints, 117
Star Pearl colors, 117
Stencil paper, wax, 79
Stencils, 79
Stencils, commercial, 89
Stencils, torn-paper, 125

T

Teflon in airbrushes, use of, 3

Testor's paints, 51, 112
Thayer and Chandler, 1
Thayer and Chandler AA airbrush, 128
Thayer and Chandler E airbrush, 5, 17
Thomas, Jack, 59
Thomas Industries, 23
Three-dimensional forms, 94
Tone intensity, controlling the, 73
Tree effects, 125
Triggering, 72
T-shirts, airbrushing on, 102
Turbo-type airbrush, 9

U

Urethanes, 110

V

Velvet fabric, 103
Versatex, 53, 102, 103

W

Wash exercises, 73, 75
Water trap, 26
Water trap, setting up the, 33
Water traps, 27
Weathering models, 114
Winsor Newton paints, 52, 129
Witlin, Ed, 68, 112
WOB-L compressor, 23, 26
Wold Airbrush Company, 2
Wood sealer, 50

About the Author

Carl Caiati is a professional writer, artist, photographer, airbrush specialist, custom painter, art director, and art instructor. He studied art at the Art Students League, New York City; advertising and editorial art at Hunter College; and photo journalism with Morris H. Jaffe.

Carl is a leading authority and airbrush artist in the art and custom automotive fields and has written several books and numerous articles on these subjects. He is currently self employed as a writer/photographer/custom painter/author. In addition, he has traveled for Badger Airbrush Company giving seminars and exhibitions on airbrush techniques and has served as contributing editor to *Motor* magazine, for which he wrote editorials and a monthly column on bodyshop and paint techniques.

Other Bestsellers From TAB

☐ **66 FAMILY HANDYMAN® WOOD PROJECTS**

Here are 66 practical, imaginative, and decorative projects . . . literally something for every home and every woodworking skill level from novice to advanced cabinetmaker: room dividers, a free-standing corner bench, china/book cabinet, coffee table, desk and storage units, a built-in sewing center, even your own Shaker furniture reproductions! 210 pp., 306 illus. 7″ × 10″.

Paper $14.95　　　　　　　　　**Hard $21.95**
Book No. 2632

☐ **THE DARKROOM BUILDER'S HANDBOOK—**
Hausman & DiRado

Have your own fully-equipped home darkroom for a fraction of the price you'd expect to pay! Picking and choosing from the features incorporated into the book's darkroom examples, you'll be able to design a ''dream'' darkroom that meets your own specific needs. Among the highlights: choosing a suitable location, the equipment and accessories you'll need, even how you can make your home darkroom pay for itself! 192 pp., 238 illus. 7″ × 10″.

Paper $12.95　　　　　　　　　**Hard $21.95**
Book No. 1995

☐ **ADVANCED AIRBRUSHING TECHNIQUES MADE SIMPLE—Caiati**

Here are all the professional tips and tricks needed to achieve the full spectrum of airbrushing effects—for retouching black-and-white and color photos, art and illustration work, mixed media, mural production, modeling and dilorama finishing, vignetting and photo montage procedures, and more! Highlighted by more than 165 illustrations. 144 pp., 168 illus. plus 27 color plates. 7″ × 10″.

Paper $14.95　　　　　　　　　**Book No. 1955**

☐ **EASY CALLIGRAPHY: THE ABCS OF HAND LETTERING—Ramsey**

Use this easy to follow handbook to learn the history of calligraphy and how to use it today: for Fun . . . to uniquely personalize correspondence, invitations, place cards, announcements, awards, posters or perhaps to create an ''original'' gift, such as a wall hanging. For Profit . . . explore ways to earn money with calligraphy, learn how to select inexpensive pens, paper, and materials. 128 pp., 168 illus. 7″ × 10″.

Paper $8.95　　　　　　　　　**Book No. 1778**

☐ **A MASTER CARVER'S LEGACY—essentials of wood carving techniques—Bouche´**

Expert guidance on the basics of wood carving from a master craftsman with over 50 years experience. All the techniques for making a whole range of woodcarved items are included. You'll learn how-to's for: basic hip carving, the basic rose, cutting of twinnings, a classic acanthus leaf, and a simple carving in the round. In no time at all you will be making many of the projects featured. 176 pp., 135 illus. 8 1/2″ × 11″.

Hard $24.95　　　　　　　　　**Book No. 2629**

☐ **BOTTLING SHIPS AND HOUSES—Roush**

Written for the novice modeler and craftsman, this unique hobby guide is packed with ideas, tips, and techniques that even the advanced builder will find useful. It shows you, step-by-step, how to design and construct any type of house, building, ship, or boat inside a bottle. From choosing the right type of bottle, to adding the all-important finishing touches . . . the author has left nothing to chance. 224 pp., 208 illus. 16 pages in full color. 7″ × 10″.

Paper $17.95　　　　　　　　　**Hard $22.95**
Book No. 1975

☐ **DESIGNING AND CONSTRUCTING MOBILES—Wiley**

Discover the fun and satisfaction of learning to create exciting mobile art forms . . . to add a personal decorator touch to your home, as unique craft projects for a school class or club, even as a new income source! All the skills and techniques are here for the taking in this excellent, step-by-step guide to designing and constructing mobiles from paper, wood, metals, plastic, and other materials. 224 pp., 281 illus. 7″ × 10″.

Paper $12.95　　　　　　　　　**Hard $19.95**
Book No. 1839

☐ **THE KITE BUILDING & KITE FLYING HANDBOOK, With 42 Kite Plans**

Here's a guide that covers everything from the history and development of the kite, and ''how kites fly'' to what you can do to design your kites for successful flight. Plus there are 42 kite plans from simple to complex so that whatever your skill level there's one for you! Each plan includes carefully detailed step-by-step instructions, blue-prints, patterns, and illustrations. 288 pp., 350 illus. 7″ × 10″.

Paper $15.50　　　　　　　　　**Book No. 1669**

*Prices subject to change without notice.

Look for these and other TAB books at your local bookstore.

TAB BOOKS Inc.
P.O. Box 40
Blue Ridge Summit, PA 17214

Send for FREE TAB catalog describing over 1200 current titles in print.